PHOTOSECRETS
LAS VEGAS

WHERE TO TAKE PICTURES

BY
ANDREW HUDSON

*"A good photograph
is knowing where to stand."*
— Ansel Adams

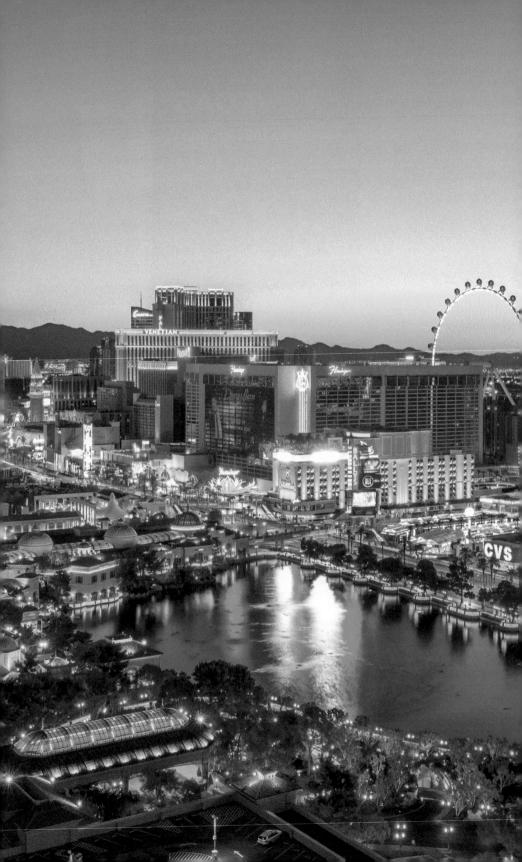

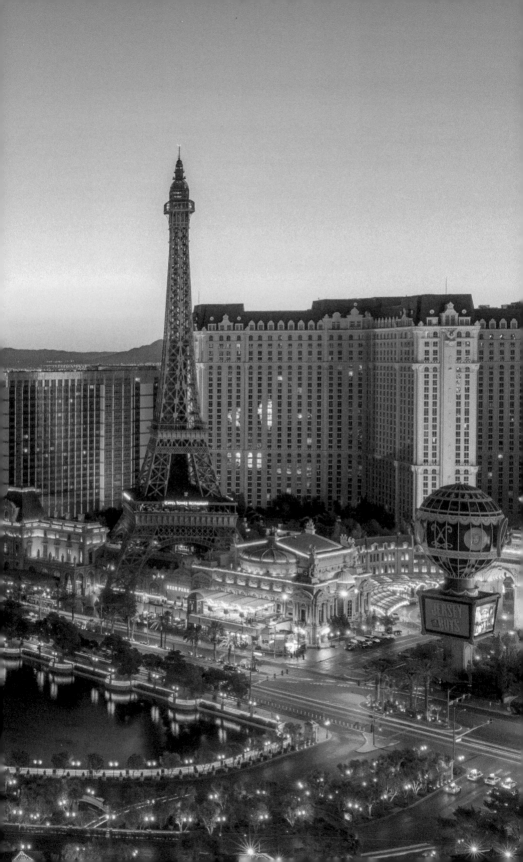

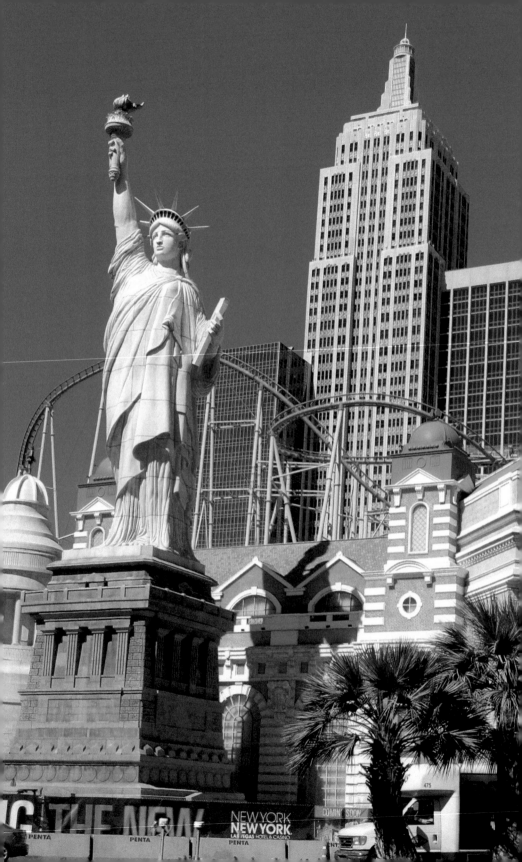

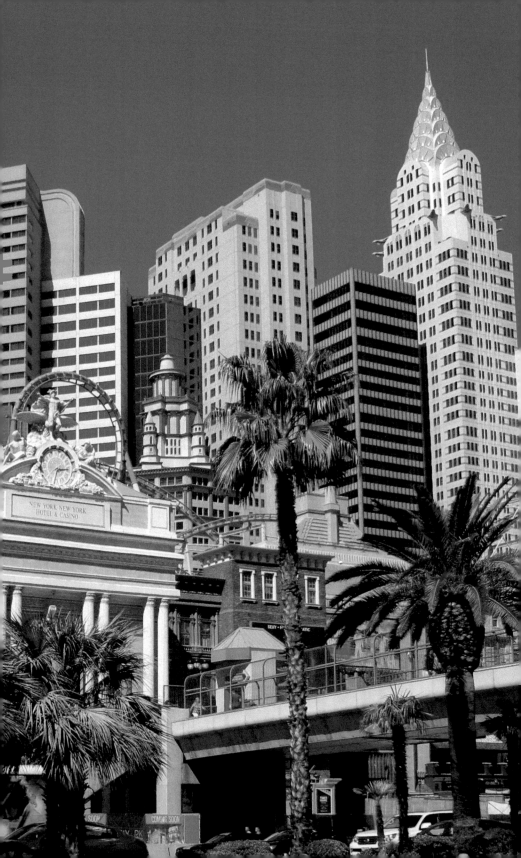

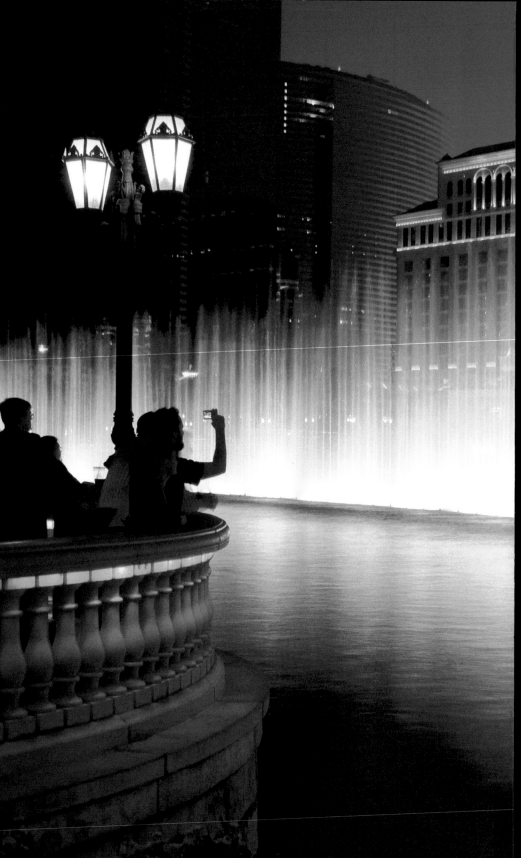

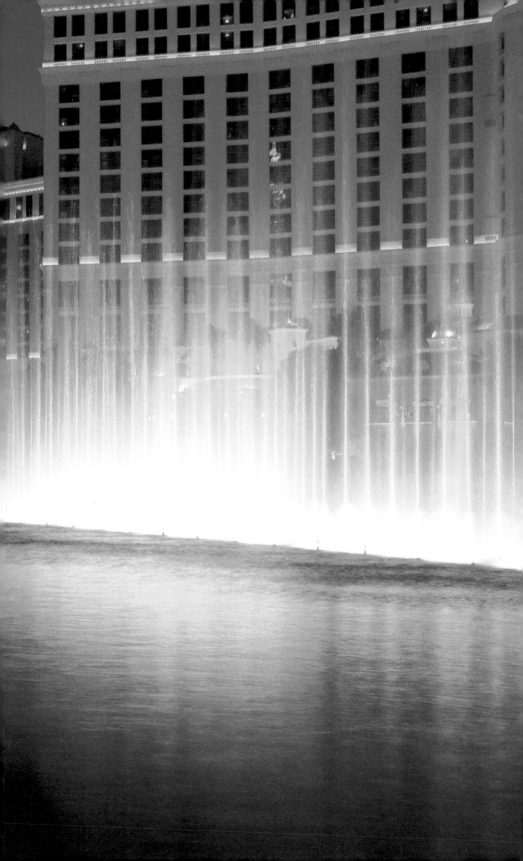

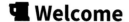

Welcome

<div align="right">By Andrew Hudson</div>

THANK YOU for reading PhotoSecrets. As a fellow fan of travelling with a camera, I hope this guide will quickly get you to the best spots so you can take postcard-perfect pictures.

PhotoSecrets shows you all the best sights. Look through, see the classic shots, and use them as a departure point for your own creations. Get ideas for composition and interesting viewpoints. See what piques your interest. Know what to shoot, why it's interesting, where to stand, when to go, and how to get great photos.

Now you can spend less time researching and more time photographing.

The idea for PhotoSecrets came during a trip to Thailand, when I tried to find the exotic beach used in the James Bond movie *The Man with the Golden Gun*. None of the guidebooks I had showed the beach, so I thought a guidebook of postcard photos would be useful. Twenty-plus years later, you have this guide, and I hope you find it useful.

Take lots of photos!

Andrew Hudson

Andrew Hudson started PhotoSecrets in 1995 and has published 24 nationally-distributed color photography books. His first book won the Benjamin Franklin Award for Best First Book and his second won the Grand Prize in the National Self-Published Book Awards.

Andrew has photographed assignments for *Macy's*, *Men's Health* and *Seventeen*, and was a location scout for *Nikon*. His photos and articles have appeared in *National Geographic Traveler*, *Alaska Airlines*, *Shutterbug*, *Where Magazine*, and *Woman's World*.

Born in England, Andrew has a degree in Computer Engineering from the University of Manchester and was previously a telecom and videoconferencing engineer. Andrew and his wife Jennie live with their two kids and two chocolate Labs in San Diego, California.

🍵 Contents

Morning

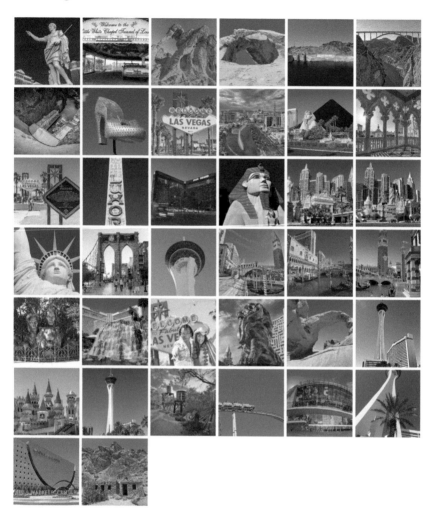

Afternoon

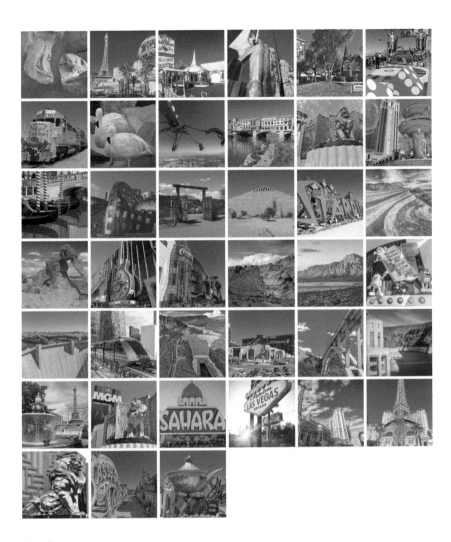

Dusk

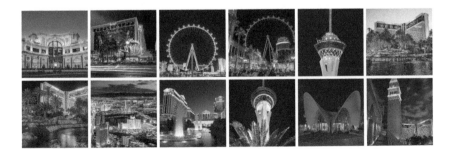

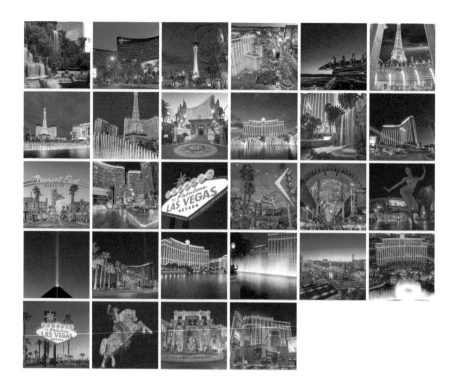

Night

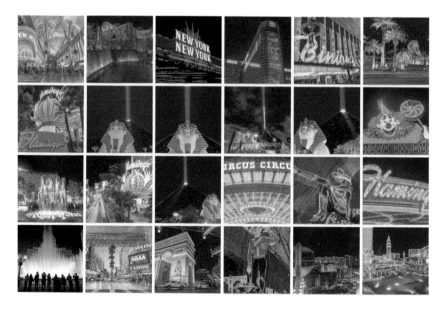

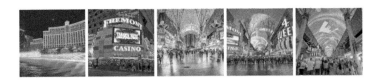

Indoors

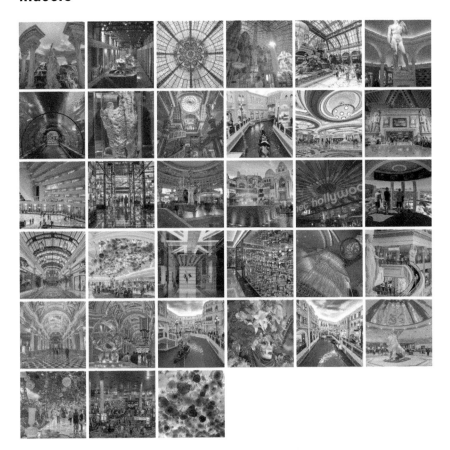

♀ Las Vegas

Las Vegas is a city and valley in southern Nevada which grew from a spring-fed meadow in the Mojave Desert to a city of gambling and entertainment. The main attractions are resort hotels along the original approach road from Los Angeles, known as the Las Vegas Strip.

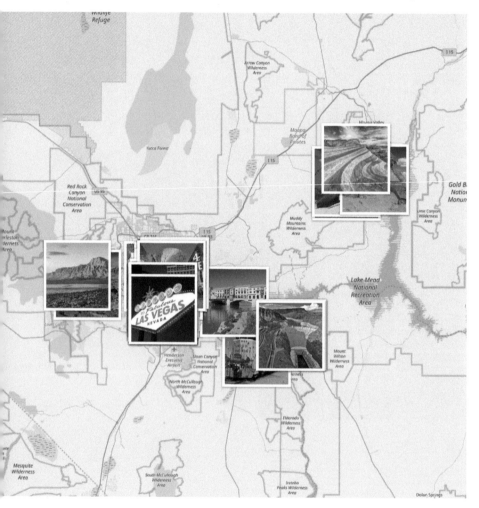

📍 Las Vegas Strip > south

The **South Strip** starts your photo tour with the most famous welcome sign in the world. Heading north, explore Southeast Asia at Mandalay Bay, Egypt at Luxor, Arthurian England at Excalibur, the Big Apple at New York-New York, and the giant MGM Grand.

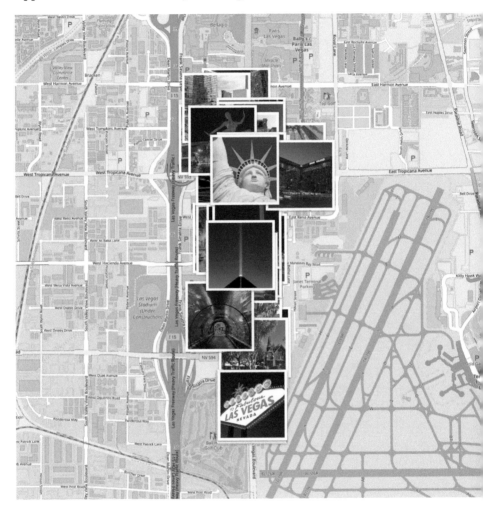

The **Center Strip** continues north past the dancing fountains of Bellagio, the Eiffel Tower of Paris, the Roman splendor of Caesars Palace, the Pacific island of The Mirage, and the Renaissance romance of The Venetian and Palazzo, the country's largest hotel complex.

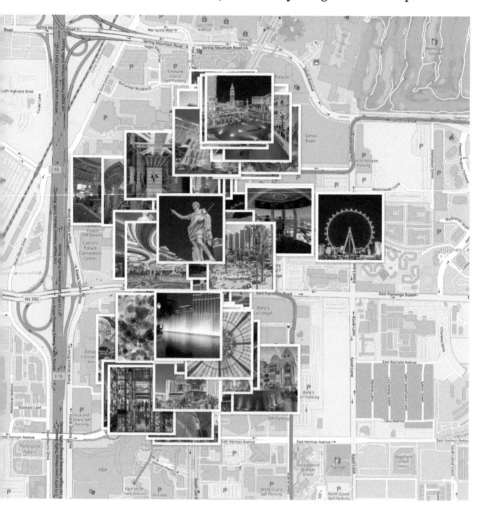

📍 Las Vegas Strip > north

The **North Strip** straddles the city line and includes the elegant Wynn Las Vegas, the family-friendly Circus Circus, and sky-high views from the tallest freestanding observation tower in the U.S. — the Stratosphere Tower.

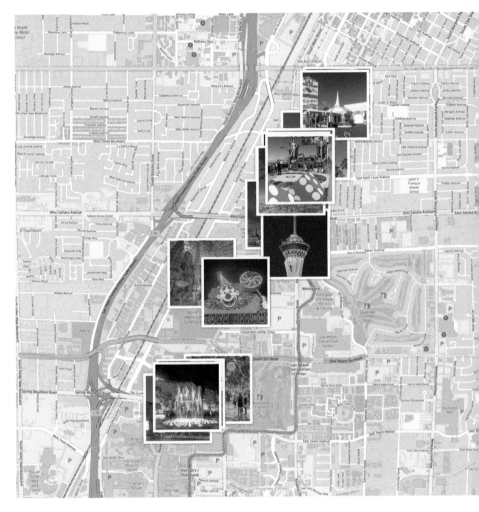

📍 Las Vegas City

The **City of Las Vegas** is north of the Las Vegas Strip and includes casinos under a video canopy at the Fremont Street Experience, old photogenic casino signs at the Neon Museum, the original Mormon Fort, and the original water source for Las Vegas at Springs Reserve.

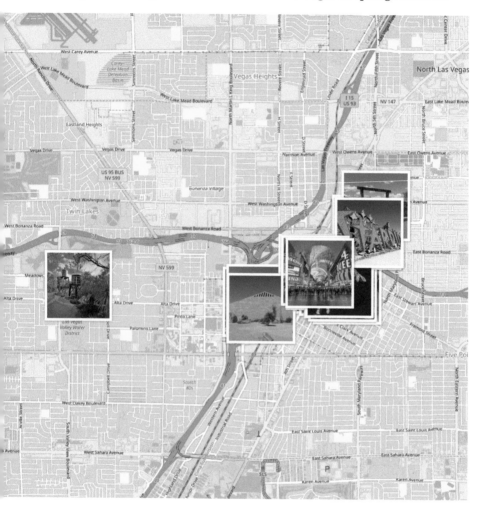

📍 Las Vegas Valley

The **Las Vegas Valley** is a 600 sq mi (1,600 km2) basin area surrounded by mountains. To the east is the awe-inspiring Hoover Dam on the Colorado River, to the west is Red Rock Canyon, and in the northeast is the photographer-friendly Valley of Fire.

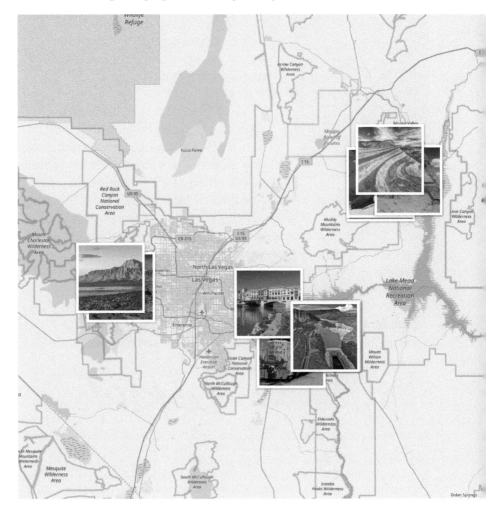

A GREAT TRAVEL photograph, like a great news photograph, requires you to be in the right place at the right time to capture that special moment. Professional photographers have a short-hand phrase for this: "F8 and be there."

There are countless books that can help you with photographic technique, the "F8" portion of that equation. But until now, there's been little help for the other, more critical portion of that equation, the "be there" part.

To find the right spot, you had to expend lots of time and shoe leather to research the area, walk around, track down every potential viewpoint, see what works, and essentially re-invent the wheel.

In my career as a professional travel photographer, well over half my time on location is spent seeking out the good angles. Andrew Hudson's PhotoSecrets does all that legwork for you, so you can spend your time photographing instead of wandering about. It's like having a professional location scout in your camera bag. I wish I had one of these books for every city I photograph on assignment.

PhotoSecrets can help you capture the most beautiful sights with a minimum of hassle and a maximum of enjoyment. So grab your camera, find your favorite PhotoSecrets spots, and "be there!"

Bob Krist has photographed assignments for *National Geographic, National Geographic Traveler, Travel/Holiday, Smithsonian,* and *Islands.* He won "Travel photographer of the Year" from the Society of American Travel Writers in 1994, 2007, and 2008 and today shoots video as a Sony Artisan Of Imagery.

For *National Geographic,* Bob has led round-the-world tours and a traveling lecture series. His book *In Tuscany* with Frances Mayes spent a month on *The New York Times'* bestseller list and his how-to book *Spirit of Place* was hailed by *American Photographer* magazine as "the best book about travel photography."

After training at the American Conservatory Theater, Bob was a theater actor in Europe and a newspaper photographer in his native New Jersey. The parents of three sons, Bob and his wife Peggy live in New Hope, Pennsylvania.

ℹ️ Introduction

Las Vegas beckons your camera with more photogenic sights on one street than anywhere else in the world. Twenty-seven of the planet's 60 largest hotels stand within four miles of each other and tempt your photography with fountains, recreated world icons and outlandish architecture.

Located in the Mojave Desert in southern Nevada, the city is named for, and grew around, green meadows fed by springs from the nearby mountains. This welcome water-stop on the Spanish Trail to Los Angeles was found by Mexican scout Rafael Rivera in 1829, and documented by American explorer John Fremont in 1844. Mormon missionaries from Utah built an adobe fort in 1855 by a creek to irrigate crops, and the Salt Lake to Los Angeles route became a railroad in 1905. The city was incorporated that year, with the railroad station anchoring Fremont Street.

In 1931, work started on today's Hoover Dam and Las Vegas' population swelled from around 5,000 citizens to 25,000, with mainly single men. To capture their business, the state of Nevada legalized local gambling the same year, beginning the city's rise to the world's gambling capital. Electricity from the dam lit Fremont Street, which became known as "Glitter Gulch."

In the 1940s, thousands of cars streamed along the new road from Los Angeles, heading to the casinos of downtown. To waylay travelers 2-1/2 miles before their destination — and to avoid the city's slot taxes — new clubs sprang up just south of the city line, making the road look like L.A.'s hip Sunset Strip. The Las Vegas Strip started with El Rancho Vegas in 1941 and gained Miami-style class with The Flamingo in 1941, opened by New York gangster Bugsy Siegel. Today's resorts are built where the famed post-war resorts of the '50s stood, including Wynn (on the Desert Inn, 1950), The Venetian (Sands, 1952), and Bellagio (Dunes, 1955).

Las Vegas today is a truly unique place. Built in the middle of nowhere and designed for fun, "Sin City" is the ultimate party town — an adult Disneyland, a place where money and imagination have run amok. Over 42 million visitors per year enjoy the "Entertainment Capital of the World", where both your wealth and marital status can change in a matter of minutes. Fortunately, as the marketing slogan says, what happens here, stays here. Elvis said it best: Viva Las Vegas.

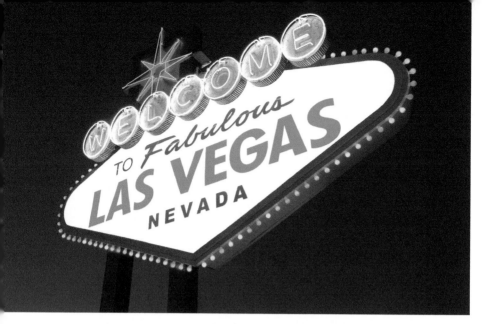

The **Welcome to Fabulous Las Vegas sign** has been greeting visitors along the main entrance road to Las Vegas since 1942. Designed by Betty Willis and conceived by local salesman Ted Rogich, the Googie-style the landmark makes the perfect backdrop for your Vegas selfie.

The sign is located at the southern end of the Las Vegas Strip, just south of the Mandalay Bay Resort. There is a small parking area in the road's median, on the south-bound side of Las Vegas Boulevard, and a paved viewing and photography area. The sign faces south so is well lit most of the day, and is lit for dusk shots.

This is a must-have "establishing shot" to start your photographic story and literally say to your viewer, Welcome to Fabulous Las Vegas.

✉ **Addr:**	5100 S Las Vegas Blvd, Las Vegas NV 89119	♀ **Where:**	36.081747 -115.172743	
❷ **What:**	Sign	⏱ **When:**	Morning	
👁 **Look:**	North	W **Wik:**	Welcome_to_Fabulous_Las_Vegas_sign	

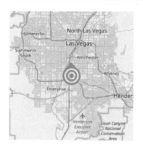
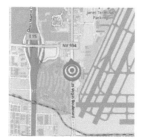
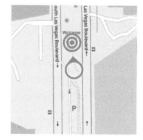

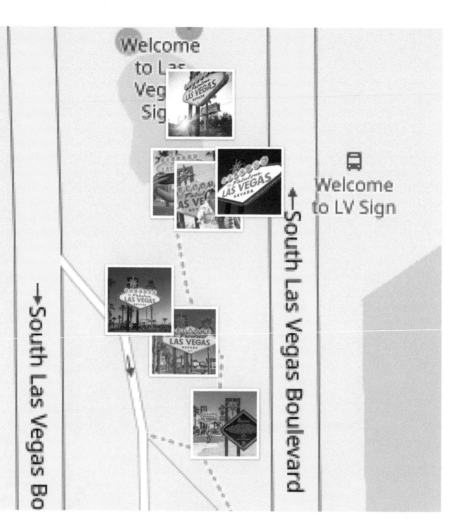

Welcome
to Las
Vegas
Sign

🚌 Welcome
to LV Sign

South Las Vegas Boulevard

South Las Vegas Bo

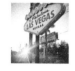

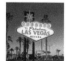

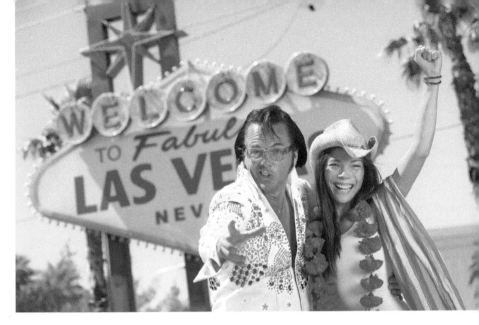

Hold the camera below eye height to include the sign and **add impact**.

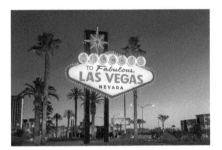

Turn on your flash to add additional light to your face and a sparkle in your eye.

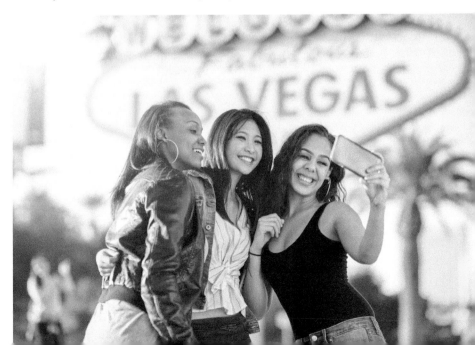

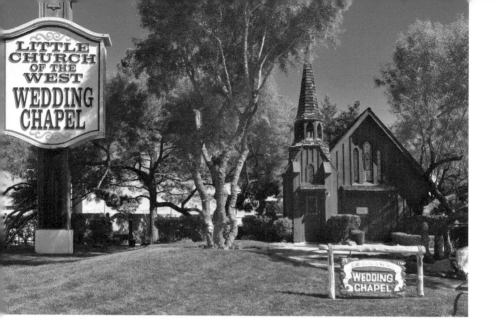

The **Little Church of the West** is a wedding chapel and the oldest building on the Las Vegas Strip. Built of redwood in 1942, the chapel was designed like a pioneer town church for the Hotel Last Frontier, the second resort opened on the Las Vegas Strip. In 1996, the chapel was moved to the current location, by the Welcome to Fabulous Las Vegas sign. These photos are from the sidewalk.

Celebrities that got married here include Judy Garland, David Cassidy, Bob Geldof, Dudley Moore, Telly Savalas, Richard Gere and Cindy Crawford, Billy Bob Thornton and Angelina Jolie, and, in the 1964 movies Viva Las Vegas, Elvis Presley and Ann-Margret.

The hanging wooden sign makes a useful and informative foreground.

✉ **Addr:**	4615 S Las Vegas Blvd, Las Vegas NV 89119	♀ **Where:**	36.086178 -115.172513	
❷ **What:**	Wedding chapel	◐ **When:**	Afternoon	
◉ **Look:**	East	Ⱳ **Wik:**	The_Little_Church_of_the_West	

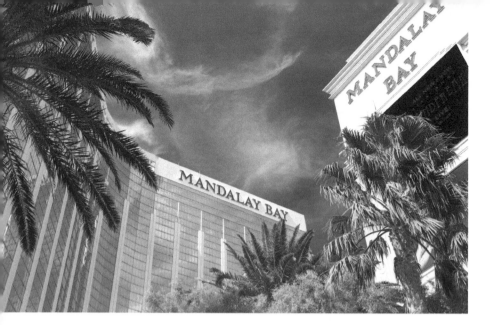

Mandalay Bay is a tropical-themed resort named for the port of Mandalay in Myanmar (Burma), as immortalized in a poem by Rudyard Kipling. The lush surroundings include palm trees and an 11-acre beach area with a lazy river and a wave pool with six-foot-high waves.

These shots are from the main pedestrian entrance, on the northeast corner, on Las Vegas Boulevard near the Luxor. Use a wide-angle lens (such as 28mm for a 35mm sensor) to exaggerate the foreground depth and add impact to your shot.

To get a soft and blurred waterfall effect, use a slow shutter speed (such as 1/8s). This will require a tripod or other support to keep the camera steady during this long exposure, otherwise all of your photo will be blurry, not just the water.

✉ **Addr:**	3940 S Las Vegas Blvd, Las Vegas NV 89119	♀ **Where:**	36.091508 -115.173099	
♟ **Owner:**	MGM Resorts • 3,209 rooms	☾ **When:**	Morning	
⚑ **Opened:**	1999	W **Wik:**	Mandalay_Bay	

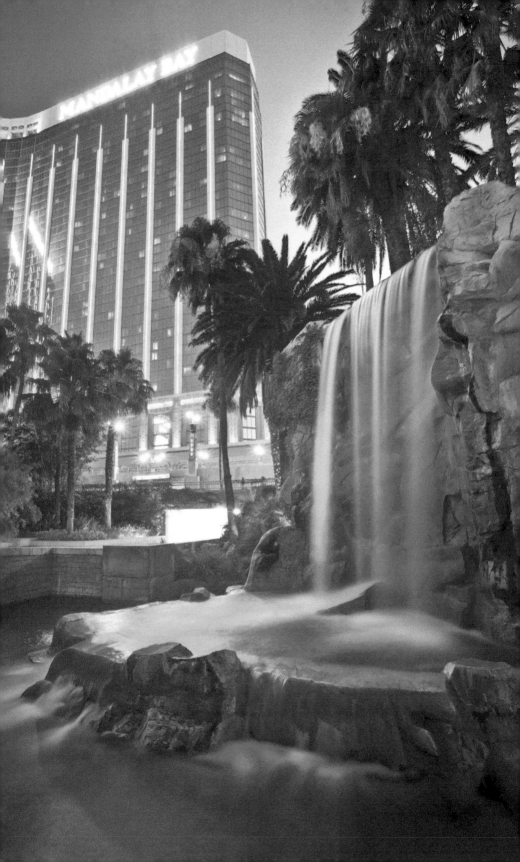

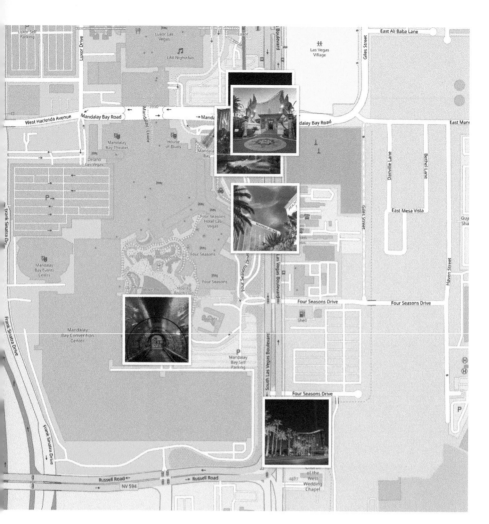

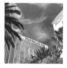 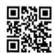 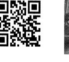

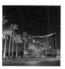

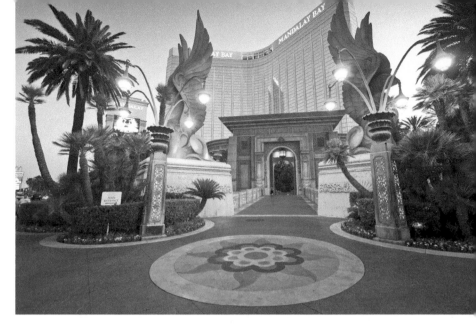

Winged griffins guard the entrance on the northeast corner (by the waterfall).

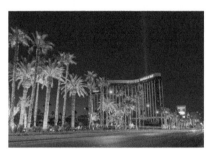
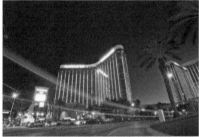

Card sharks meet real sharks at Shark Reef, an aquarium with a tunnel.

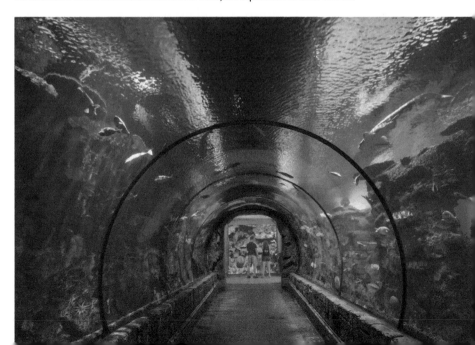

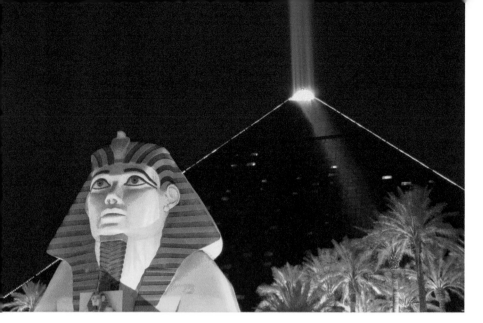

Luxor Las Vegas is the most architecturally distinctive hotel in Las Vegas. Themed for Ancient Egypt, a Great Sphinx of Giza fronts a 30-story-high, stark black pyramid.

You can photograph the Sphinx from the raised tram station (right and below left) and from Las Vegas Boulevard (above and below right).

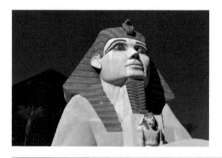

✉ **Addr:**	3900 S Las Vegas Blvd, Las Vegas NV 89119	♀ **Where:**	36.095892 -115.173224
✿ **Owner:**	MGM Resorts • 4,407 rooms	◑ **When:**	Morning
⛬ **Opened:**	1993	W **Wik:**	Luxor_Las_Vegas

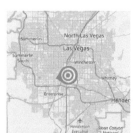
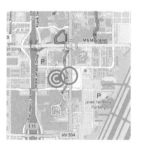

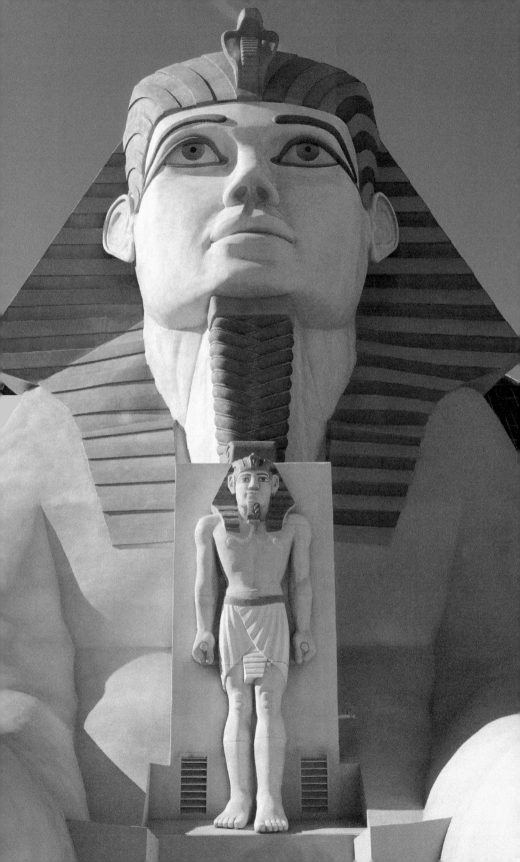

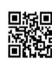

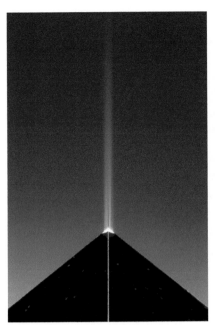
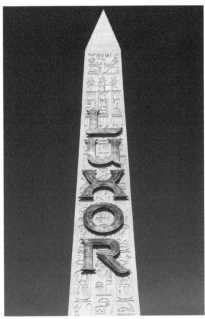

At the apex of the Luxor pyramid is a 42-billion-candlepower xenon beacon which, at night, sends a shaft of blue-white light 10 miles into space. The Luxor Sky Beam is the world's brightest artificial light and is visible to pilots up to 250 miles away. In a city of so many great dusk shots, this makes a welcome night shot, for after a nearby dusk shot. The two shots below are from Las Vegas Boulevard, by the marquee obelisk, which you can walk under.

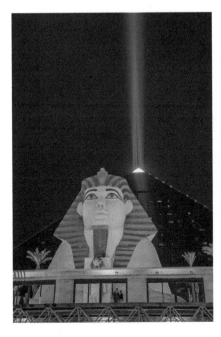
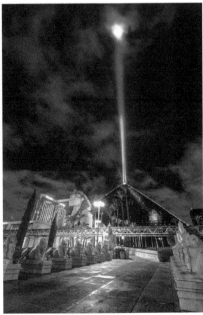

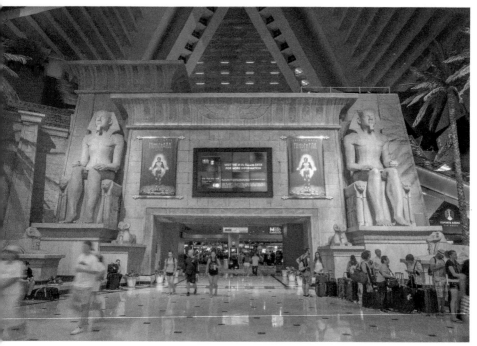

Inside, a replica of the great Temple of Ramses II forms the entrance, and the elevators at each corner rise at 45-degree angles. The pyramid's atrium is one of the world's largest and could accommodate ten 747 jetliners stacked one atop another. Fortunately, it doesn't.

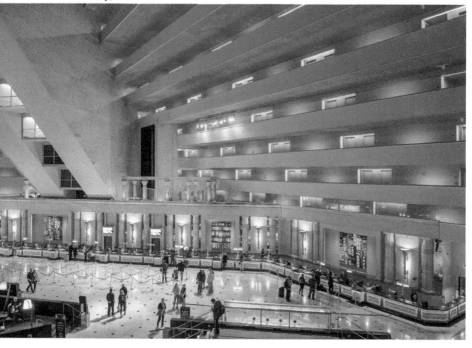

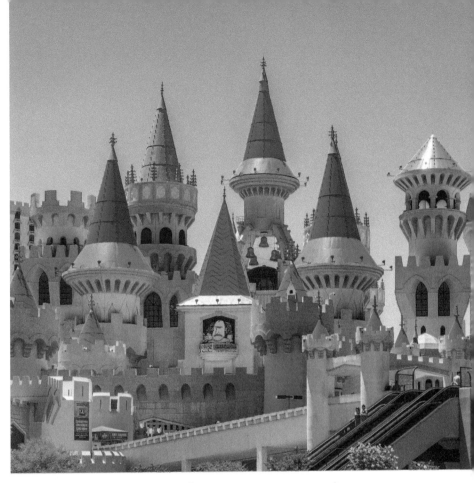

Excalibur Hotel and Casino is a giant Medieval English castle, complete with a drawbridge and crenelated roofs. The best shot is from across the street by the Statue of Liberty, using a long lens to compress the perspective and emphasize the colorful turrets.

✉ **Addr:**	3850 S Las Vegas Blvd, Las Vegas NV 89109	♥ **Where:**	36.101093 -115.173299
⚚ **Owner:**	MGM Resorts • 3,981 rooms • 1990	◔ **When:**	Morning
◉ **Look:**	Southwest	W **Wik:**	Excalibur_Hotel_and_Casino

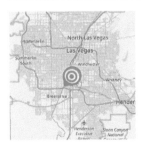
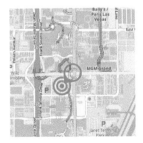

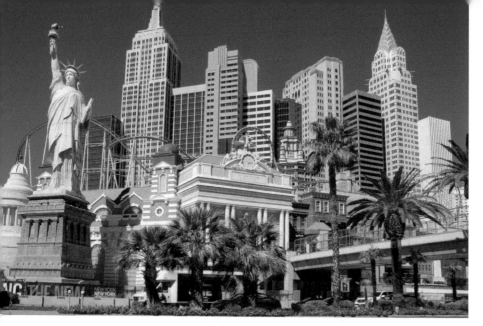

New York-New York Hotel & Casino is "the greatest city in Las Vegas." All 2,023 guest rooms are housed in one-third-scale reproductions of twelve Manhattan skyscrapers, such as the Empire State Building and the Chrysler Building.

Inside, Art Deco flourishes abound. The casino is themed for Central Park; shops line Park Avenue; and delis and pizza joints fill a Greenwich Village-style neighborhood, complete with brownstone buildings, fire escapes, and manhole covers that spew steam.

In a mini New York Harbor on the southeast corner stands a half-scale replica of the Statue of Liberty herself. These views are from across the street by the MGM Grand lion and are best in the morning, when the light is in the east. You could use a polarizer filter to make the sky a deeper blue.

✉ **Addr:**	3790 S Las Vegas Blvd, Las Vegas NV 89109	♥ **Where:**	36.101332 -115.172591	
♟ **Owner:**	MGM Resorts • 2,024 rooms • 1997	◐ **When:**	Morning	
👁 **Look:**	West-northwest	W **Wik:**	New_York-New_York_Hotel_and_Casino	

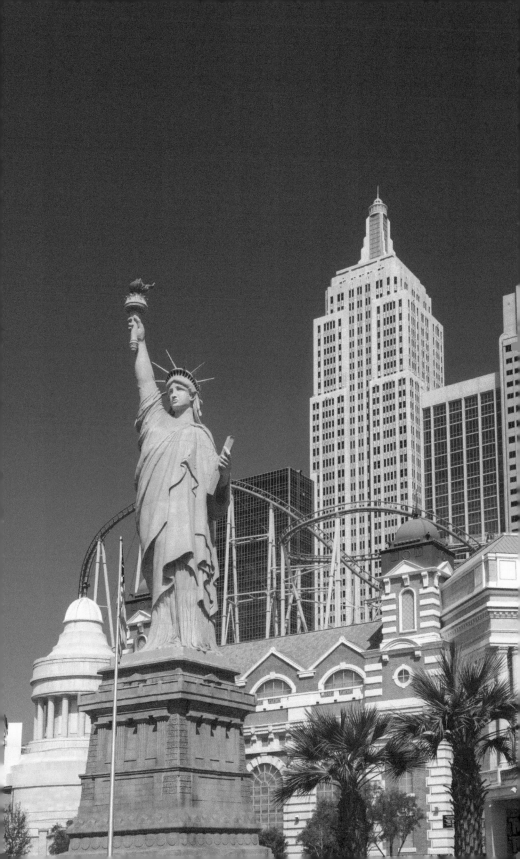

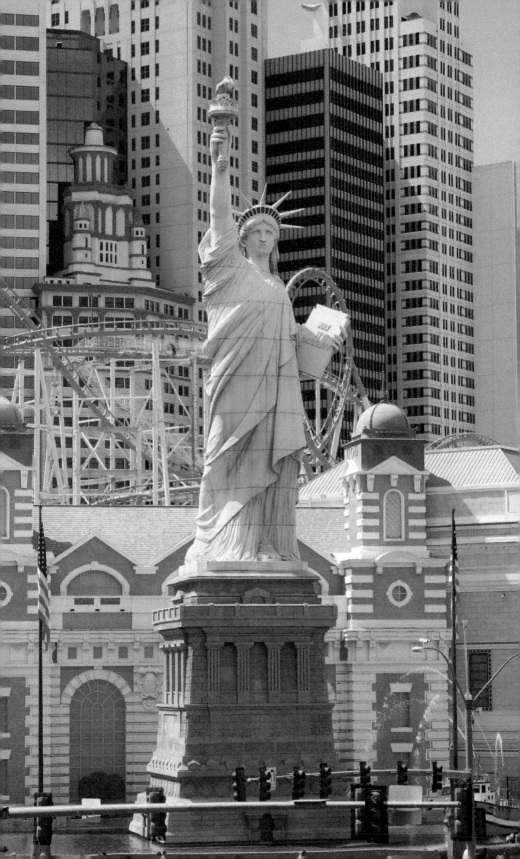

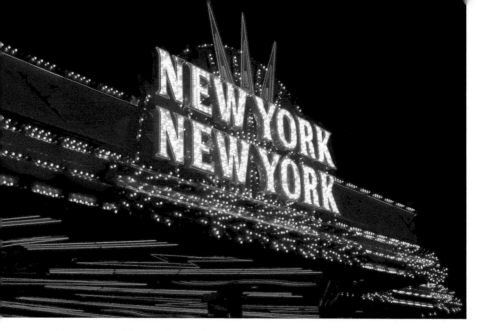

The porte-cochère on the south side has a night-lit sign.

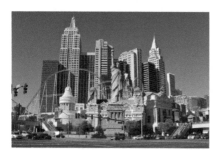

The Statue of Liberty replica, looking up from the base.

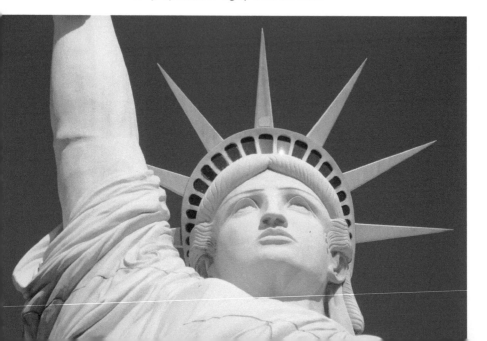

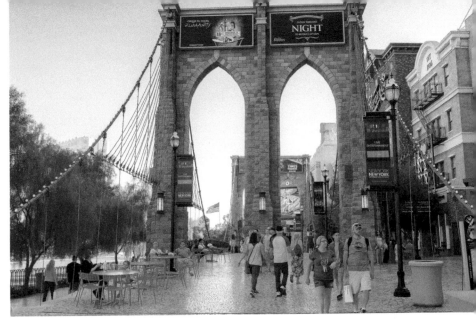

A one-fifth-size Brooklyn Bridge carries more pedestrians than the real thing.

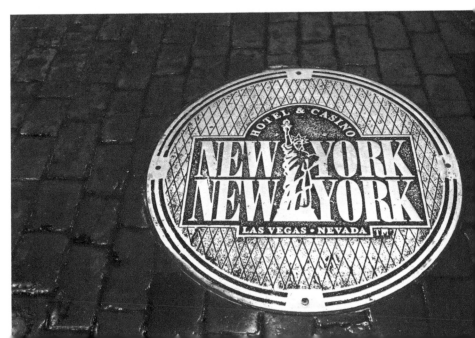

A roller coaster roars inside, outside and around the skyscrapers.

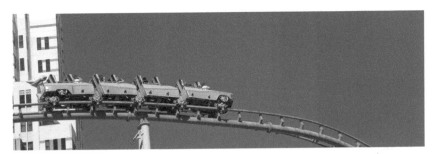

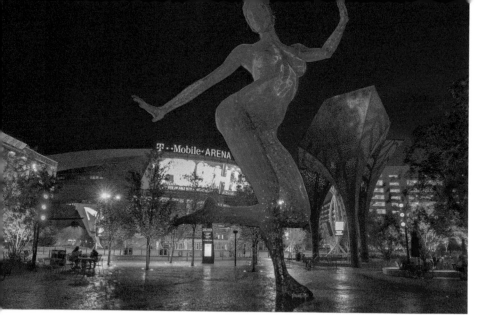

The Park is an immersive outdoor dining and entertainment district by New York-New York, with T-Mobile Arena, a sports and entertainment venue. In the center is Bliss Dance, a 40-foot-tall sculpture of a dancing woman by artist Marco Cochrane, inspired by his first visit to Burning Man festival.

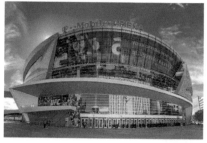

✉ **Addr:**	6 Park Ave, Las Vegas NV 89109	♀ **Where:**	36.103525 -115.175627	
⚱ **Owner:**	MGM Resorts	☾ **When:**	Morning	
👁 **Look:**	West-southwest	↔ **Far:**	28 m (92 feet)	

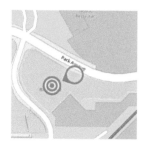

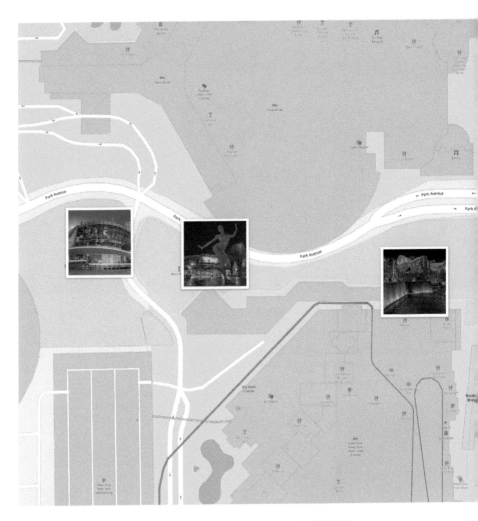

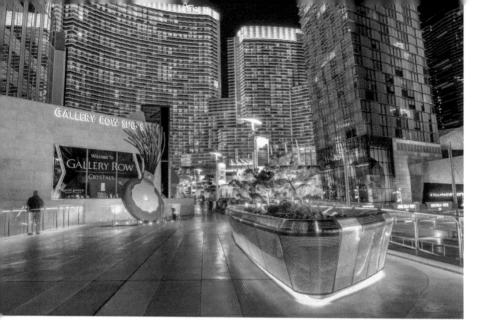

CityCenter is a 16 million-square-foot mixed-use urban complex including the Aria Resort and Casino. Through the center runs the Aria Express tram to Park MGM to the south and the Bellagio to the north. In the background of these shots are the Veer Towers, twin condominium towers which lean leaning 4.6 degrees in opposite directions.

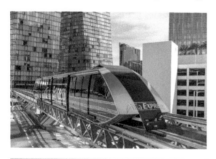

✉ **Addr:**	3730 Las Vegas Fwy, Las Vegas NV 89109	♀ **Where:**	36.106576 -115.174211
⚲ **Owner:**	MGM Resorts • 5,891 rooms • 2009	◑ **When:**	Anytime
👁 **Look:**	West	W **Wik:**	CityCenter

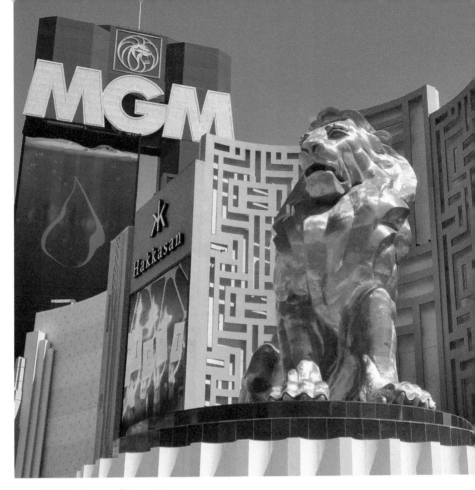

The **MGM Grand Las Vegas** is named for the movie company Metro-Goldwyn-Mayer, whose mascot is a roaring lion. On the southwest corner is Leo, 45-feet (14 m) tall and the largest bronze statue in the United States, and the second largest in the world.

✉ **Addr:**	3799 Las Vegas Monorail, Las Vegas NV 89109	♀ **Where:**	36.101115 -115.172406
♟ **Owner:**	MGM Resorts • 6,852 rooms • 1993	◑ **When:**	Afternoon
◉ **Look:**	North	W **Wik:**	MGM_Grand_Las_Vegas

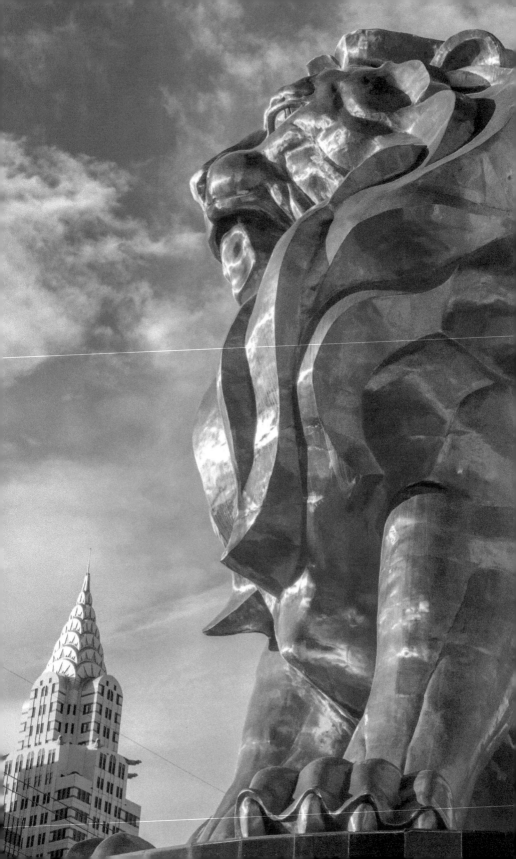

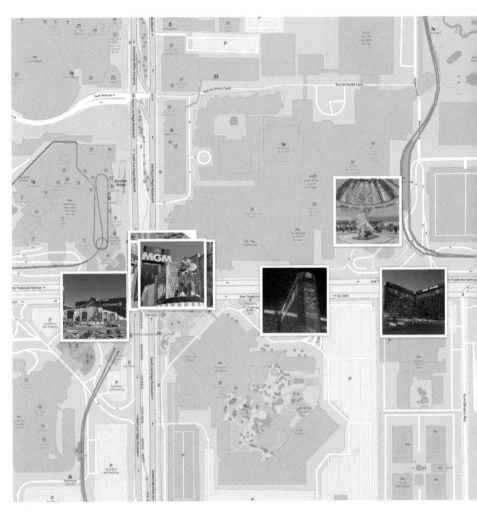

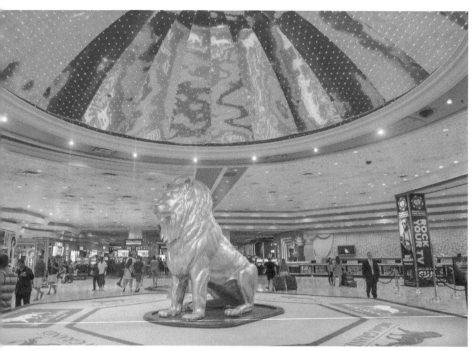

Above: Another Leo stands in the center of the lobby, ensuring that every guest pays their bill. Below: The exterior (as viewed from across the street near Hooter's) is "Emerald City" green, for MGM's most famous movie, *The Wizard of Oz* (1939).

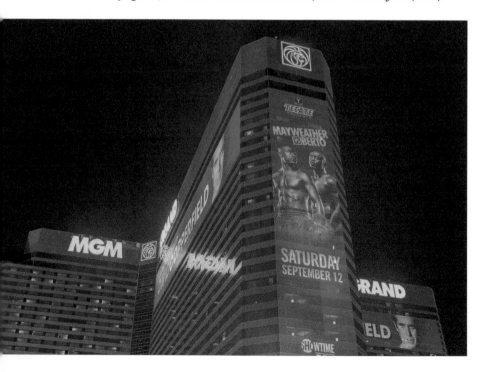

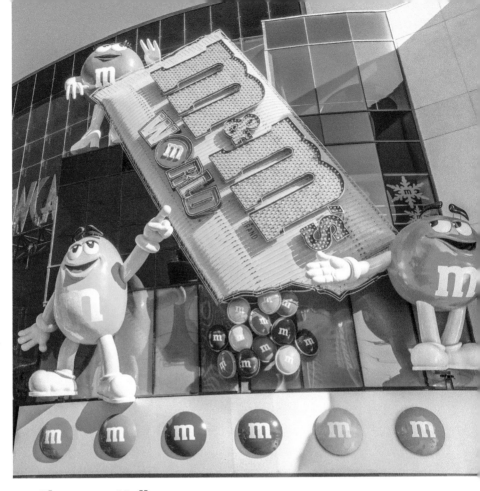

The **Showcase Mall** north of the MGM Grand has a landmark facade. Here you can photograph a colossal bag of M&M's, a 100-foot (30 m) tall bottle of Coca-Cola, and a three-story-high Gibson Les Paul guitar.

✉ **Addr:**	3785 S Las Vegas Blvd, Las Vegas NV 89109	♀ **Where:**	36.103248 -115.172631
❓ **What:**	Shopping mall	⏲ **When:**	Afternoon
⛲ **Opened:**	1996	W **Wik:**	Showcase_Mall

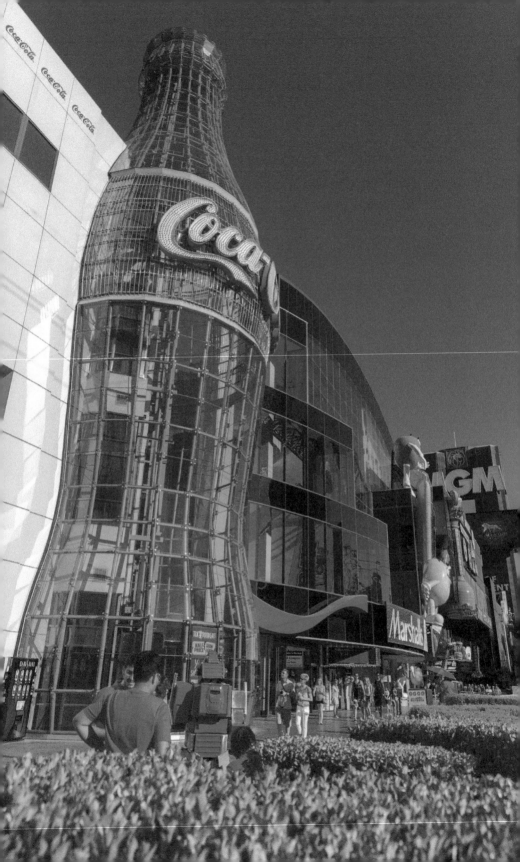

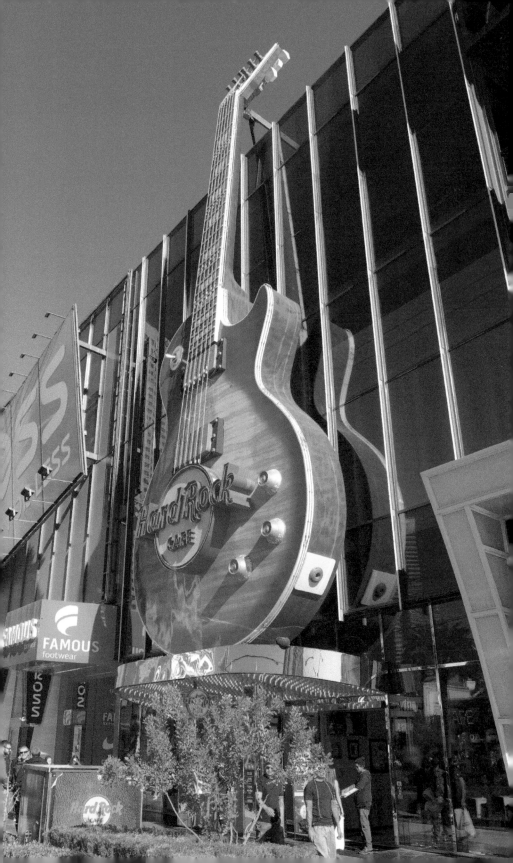

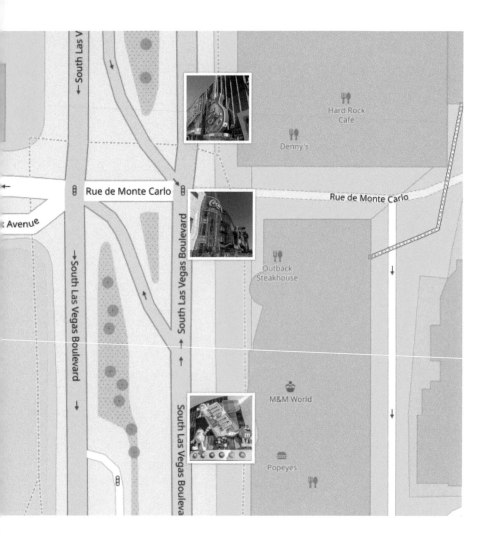

South Las V

Rue de Monte Carlo

Avenue

South Las Vegas Boulevard

South Las Vegas Boulevard

South Las Vegas Boulevard

South Las Vegas Boulevard

South Las Boulevard

Hard Rock Cafe

Denny's

Rue de Monte Carlo

Outback Steakhouse

M&M World

Popeyes

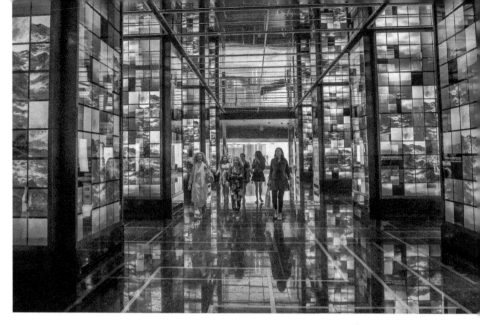

The **Cosmopolitan of Las Vegas** is the most expensive hotel built in the United States, costing over $4 billion. The luxury resort has a photogenic lobby with pillars of colorful video screens (above).

 The north-facing rooms have the best skyline view of the Las Vegas Strip, with the Bellagio fountains and the Eiffel Tower at Paris Las Vegas. Unfortunately, there is no public area at the top of the Boulevard Tower (east) or the Chelsea Tower (west) and you'll have to spend (a lot of) money and arrange to get a high-floor, north-side ("Fountain View") room. Fortunately, many rooms have a balcony ("terrace") for a clear view and staying here allows you to photograph the dusk and predawn. Or you could just enjoy the photos in this guide and save your money for something sensible, like gambling.

✉ **Addr:**	3708 S Las Vegas Blvd, Las Vegas NV 89109	📍 **Where:**	36.109764 -115.175884
⚲ **Owner:**	Blackstone • 3,027 rooms	◑ **When:**	Morning
♨ **Opened:**	2010	W **Wik:**	Cosmopolitan_of_Las_Vegas

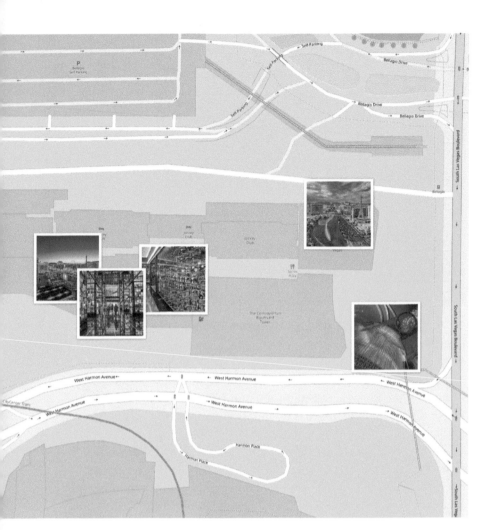

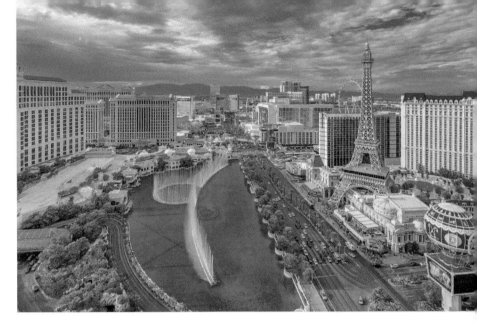

The view from the east tower (above) and west tower (below, at dawn).

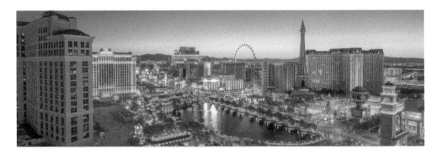

A magnificent chandelier in the entrance.

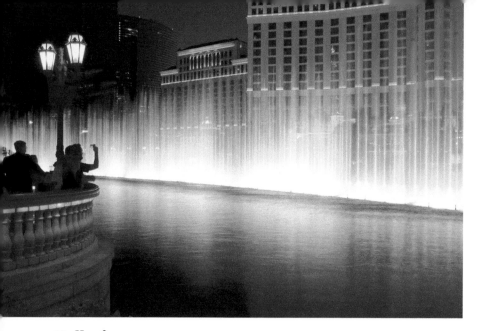

Bellagio is the most camera-attracting resort in Las Vegas due to an 8-acre man-made lake that comes to life with *The Fountains of Bellagio*. Over 1,200 synchronized nozzles wave and shoot water, coordinated with 4,500 lights and choreographed to popular music.

There are many places to photograph the fountains. Along the Strip is a 1,000-foot-long (300 m) promenade with multiple viewing bays where balustrades and decorative street lights offer romantic foregrounds (above). On the west side, the entrance walkway and lake-shore restaurants provide views with the Eiffel Tower replica in the background. And there are skyline views from the Eiffel Tower Viewing Deck (right) and lake-facing rooms at the Bellagio, the Cosmopolitan and the Flamingo.

From every angle, Bellagio is bellissimo.

✉ **Addr:**	3600 S Las Vegas Blvd, Las Vegas NV 89109	♀ **Where:**	36.113072 -115.173259
⚑ **Owner:**	MGM Resorts • 3,950 rooms • 1998	☽ **When:**	Morning
👁 **Look:**	South-southwest	W **Wik:**	Bellagio_(resort)

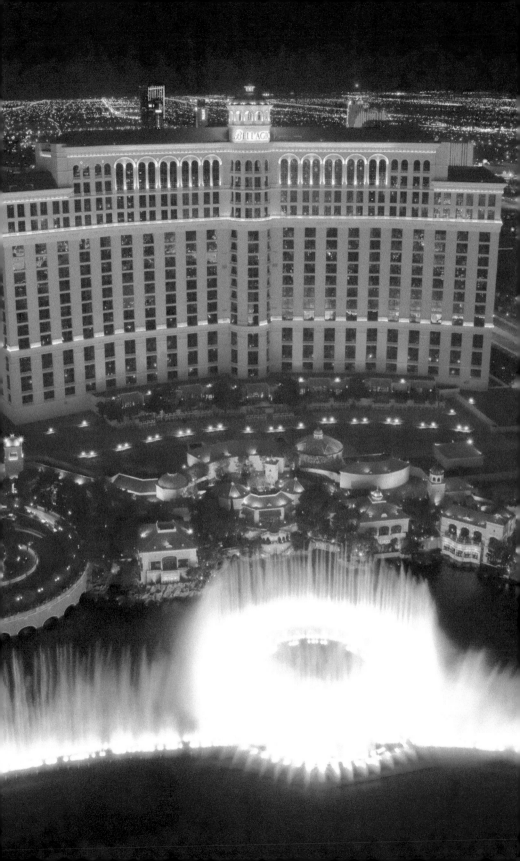

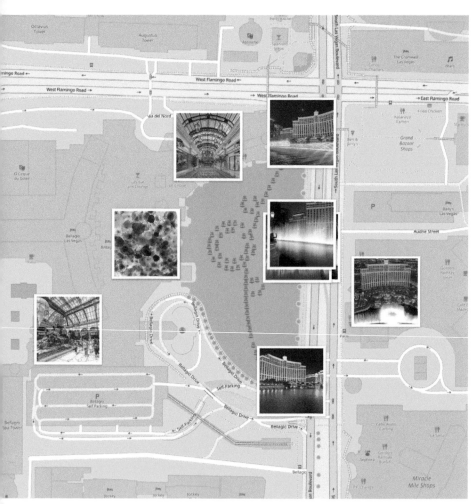

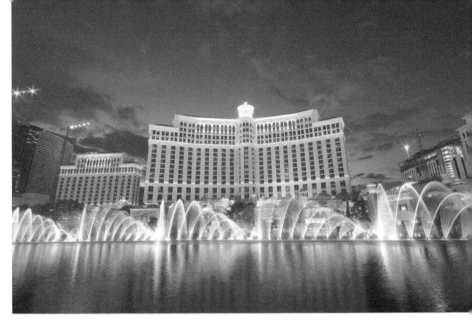

You can photograph the fountains from the sidewalk promenade along Las Vegas Boulevard. Dusk is the best time, when the white-lit fountains contrast with the blue/purple sky. To keep your camera steady, use a tripod or make a support on the wall and use the self-timer.

In the center of the lake are sixteen jets that shoot water up to 460 feet (140 m) high, cracking like cannon shot as they thrust skyward. The free shows occur every 30 minutes in the afternoons and early evenings, and every 15 minutes from 8 pm to midnight.

Step back and include the audience to provide a silhouette foreground and sense of scale.

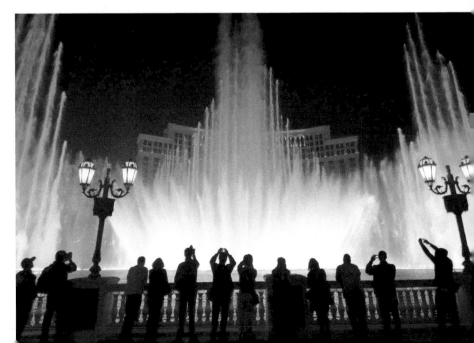

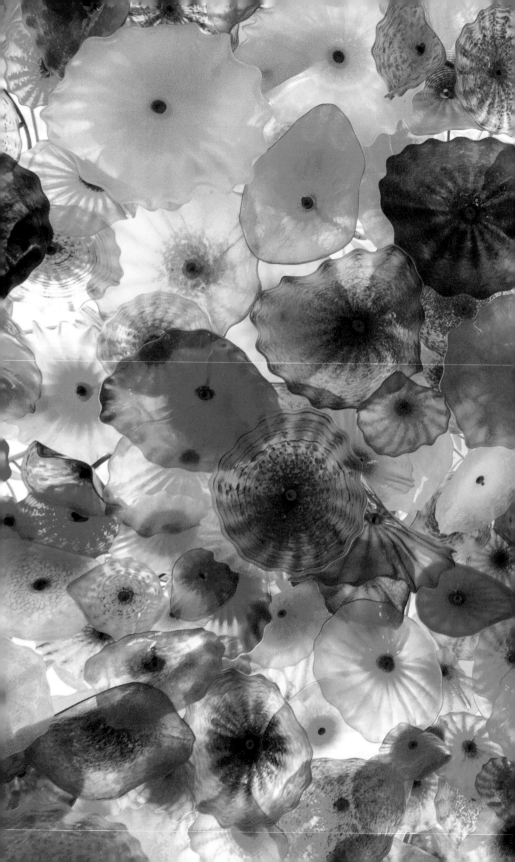

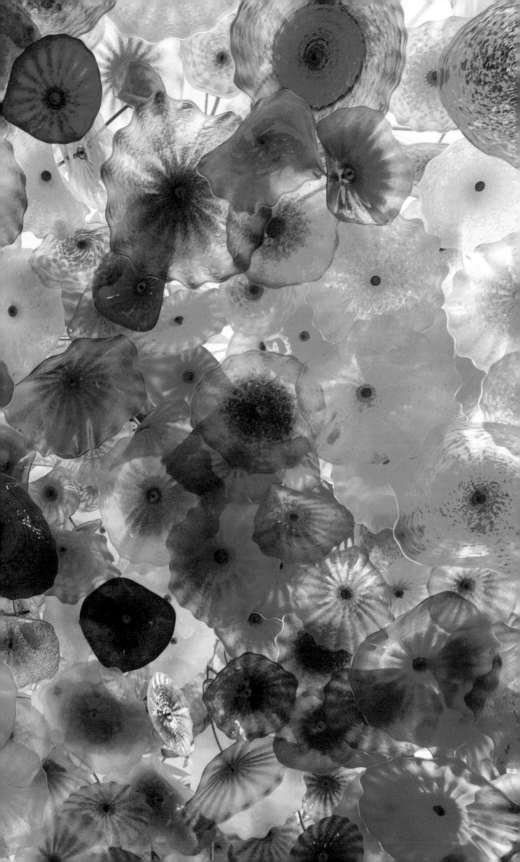

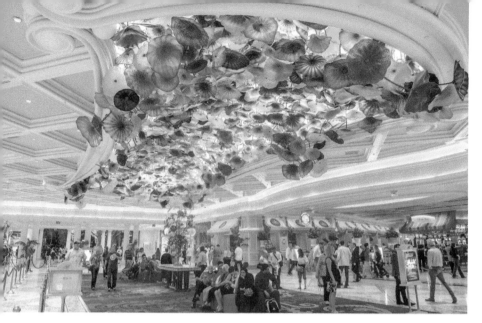

In the lobby is the world's largest glass sculpture, *Fiori di Como*.

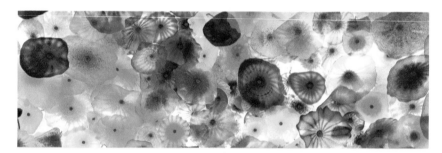

Over 2,000 glass flowers were hand-blown by **Seattle-based artist Dale Chihuly.**

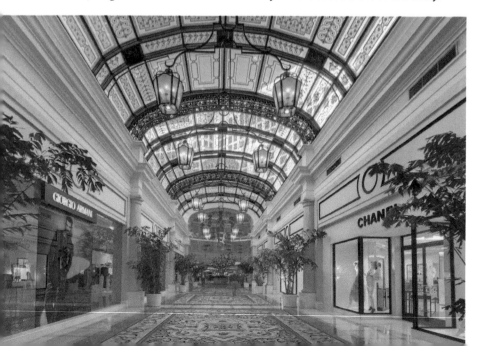

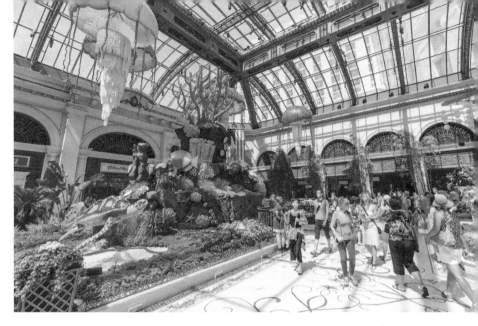

The Conservatory and Botanical Gardens is housed under a 50-foot glass ceiling.

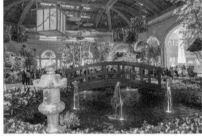

The kaleidoscope of fragrant fresh flowers is changed out five times a year.

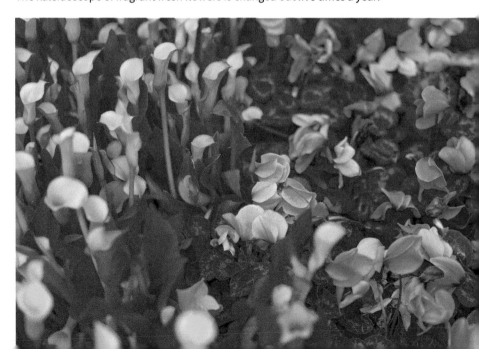

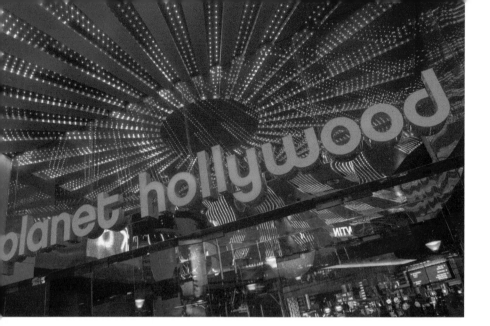

Planet Hollywood Las Vegas is a hotel and casino named for the movie-celebrity restaurant chain. You can photograph the pedestrian entrance near the northwest corner (above) and the giant yard-long margarita glass at La Salsa in the Miracle Mile Shops (below).

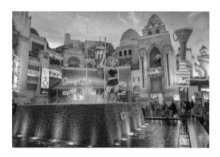

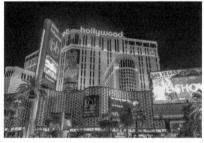

✉ **Addr:**	3667 S Las Vegas Blvd, Las Vegas NV 89109	♀ **Where:**	36.110714 -115.172594
⚲ **Owner:**	Caesars Ent. • 2,567 rooms	☽ **When:**	Afternoon
⚱ **Opened:**	2000	W **Wik:**	Planet_Hollywood_Las_Vegas

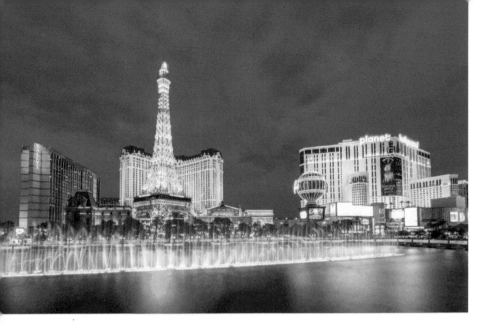

Paris Las Vegas brings Vive La France to Viva Las Vegas. Opened in 1999, the hotel exudes the very essence of the City of Light via exquisite details and replica monuments.

In the center, straddling the casino, is a half-scale Eiffel Tower, built from Gustave Eiffel's original drawings. Glass elevators whisk mesdames et messieurs to a gourmet restaurant and viewing deck with views of the Strip. C'est magnifique.

At the entrance is an Around the World in Eighty Days balloon and two-thirds scale replicas of L'Arc de Triomphe, the Paris Opera House, and the Louvre. Inside, winding cobblestone streets are lined with gaslamp-fronted French bistros and restaurants where the motto is always "let them eat cake."

These views are from the entrance driveway of Bellagio.

✉ **Addr:**	3655 S Las Vegas Blvd, Las Vegas NV 89109	♀ **Where:**	36.110815 -115.173315
♈ **Owner:**	Caesars Ent. • 2,916 rooms • 1999	☀ **When:**	Afternoon
👁 **Look:**	North-northeast	Ⓦ **Wik:**	Paris_Las_Vegas

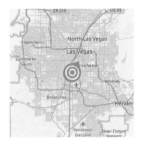 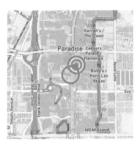

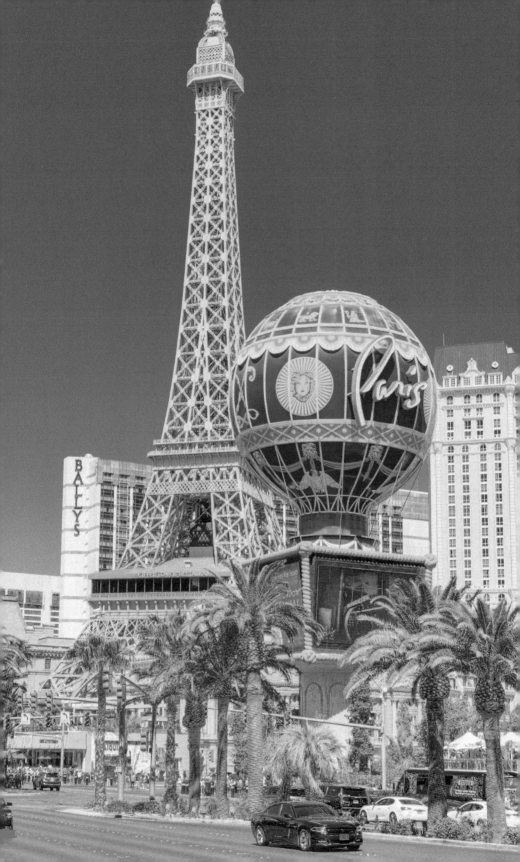

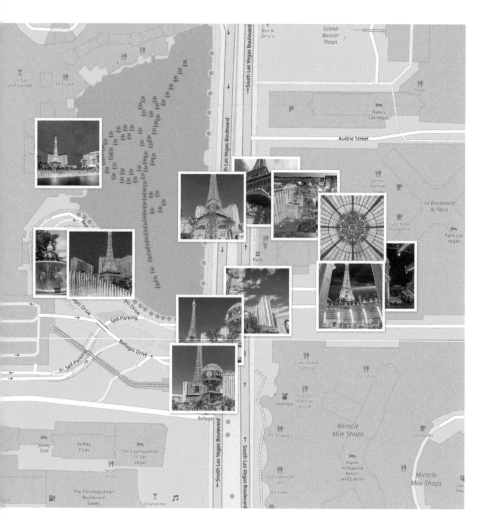

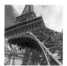

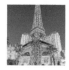

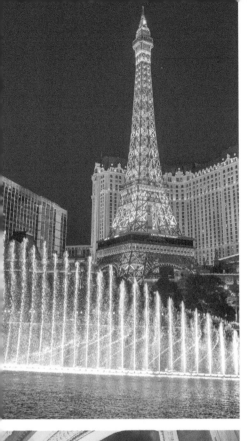
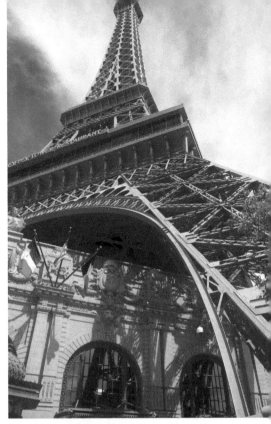
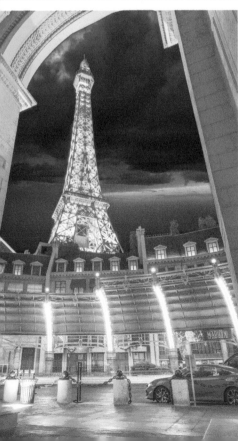
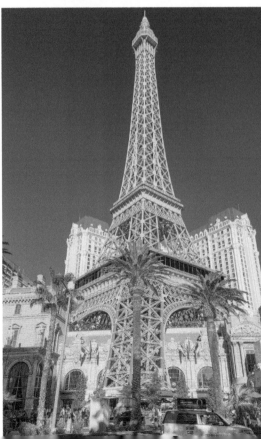

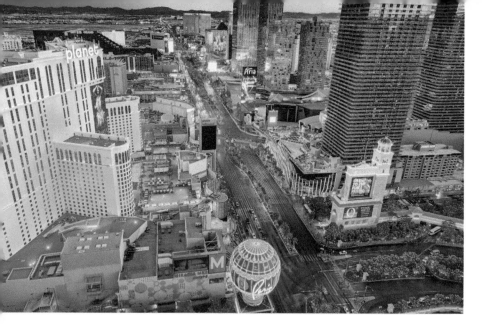

The Eiffel Tower Viewing Deck [paid admission] has views of the Strip.

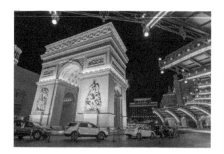 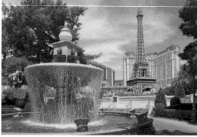

The Arc de Triomphe; Bellagio entrance fountain; stained-glass lobby skylight.

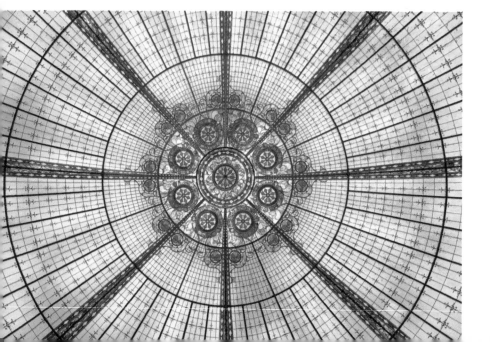

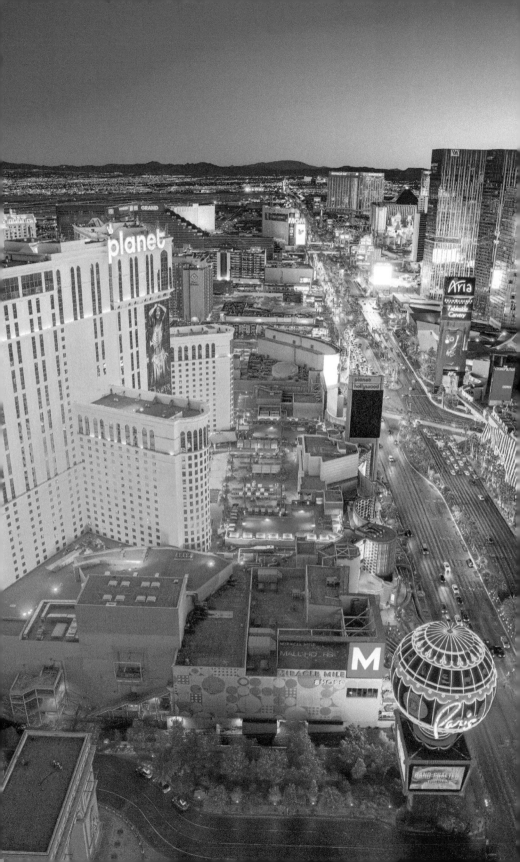

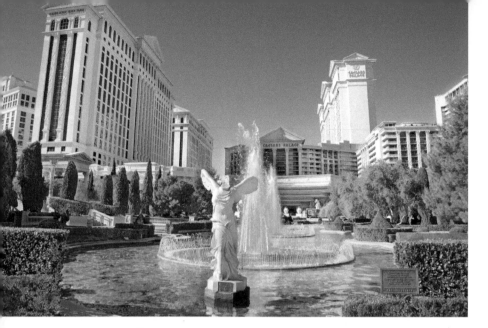

Caesars Palace presents the lavish luxury of ancient Rome.
Friends, Romans, gamblers — you are all treated like a Caesar in this
sprawling hotel opened in 1966 by Jay Sarno, and renovated several
times since. Quintessential themed Vegas, the hotels is a Hollywood,
Greco-Roman, Art Deco fantasy.

The postcard view features a replica Nike (*Winged Victory of
Samothrace*) and a pool with fountains. This view is from the sidewalk
along Las Vegas Boulevard, and the best times are in the morning
(above) and, like everywhere else on the Strip, at dusk.

All hail The Forum Shops at Caesars, the most profitable mall by
square foot in Las Vegas. The towering entrance hall on Las Vegas
Boulevard has spiral escalators (right).

✉ **Addr:**	3500 S Las Vegas Blvd, Las Vegas NV 89109	♀ **Where:**	36.117395 -115.173116
⚱ **Owner:**	VICI Properties / Caesars Ent.	☾ **When:**	Morning
👁 **Look:**	West-southwest	W **Wik:**	Caesars_Palace

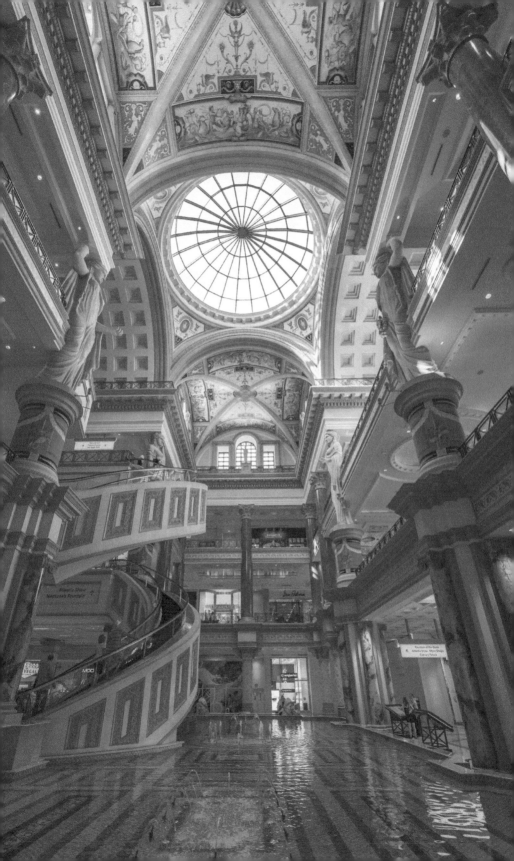

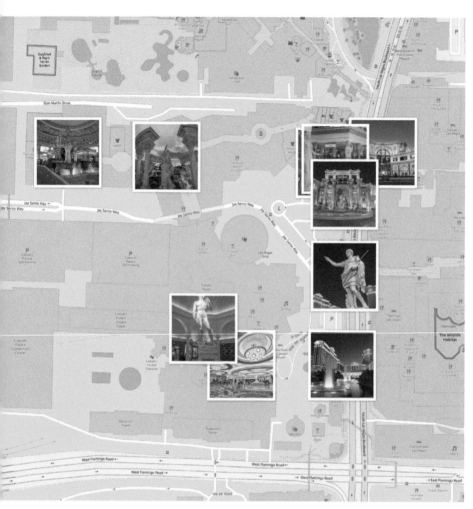

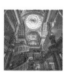

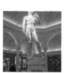

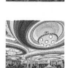

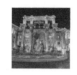

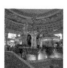

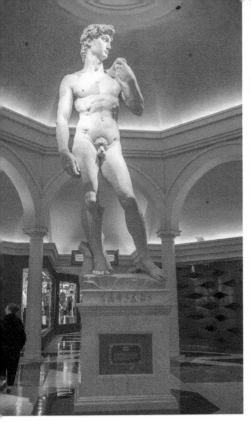 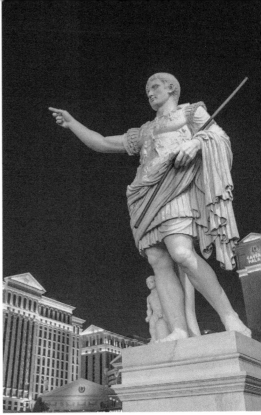

Inside, along the Appian Way, is a replica of Michelangelo's *David* statue (above left), made of Carrara marble. Outside, by the road entrance, Augustus Caesar himself hails a taxi (above right), standing 20-feet (6.1 m) tall. The lobby (below) has more statues, and swirling circles.

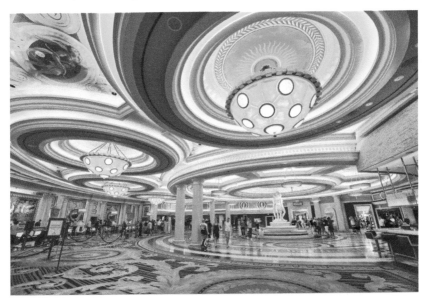

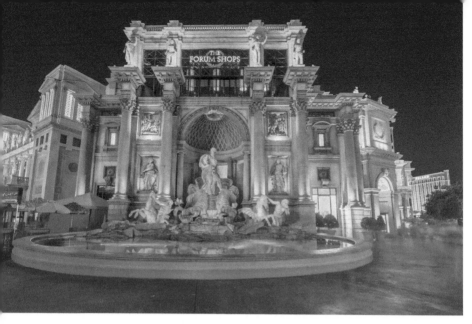

A replica Trevi Fountain (above) flows outside The Forum Shops at Caesars.

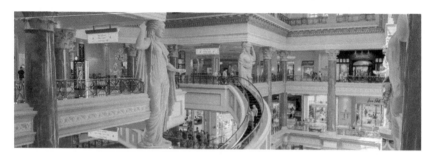

Caryatids and spiral escalators; The Fall of Atlantis show; the Fountain of the Gods.

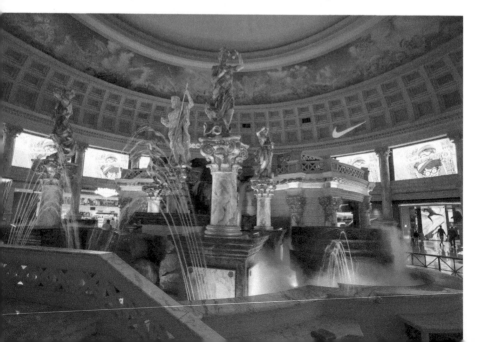

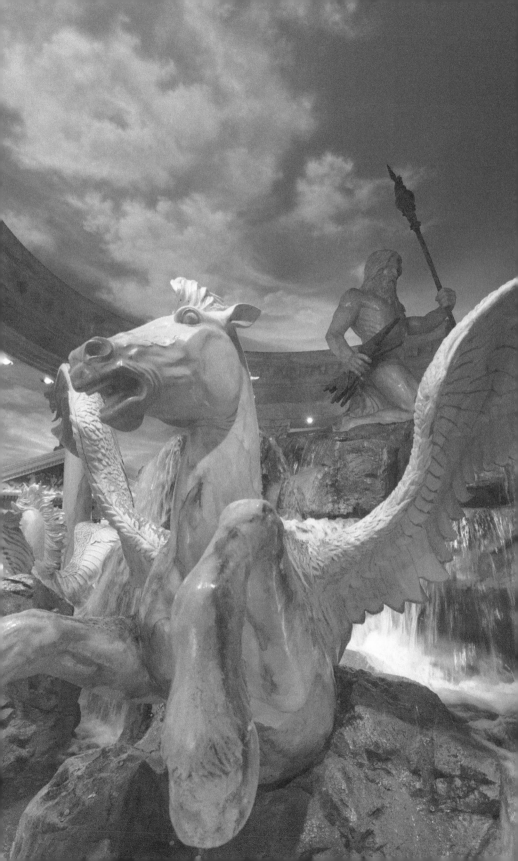

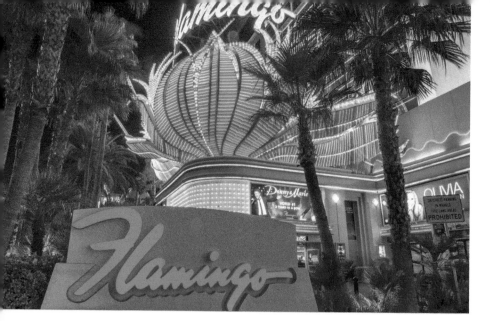

Flamingo Las Vegas offers photographers a splash of Instagram-popular pink. Opened in 1946 by mob man Benjamin "Bugsy" Siegel, the hotel was reputedly named for his longtime mistress Virginia Hill, a dancer nicknamed the Flamingo for her red hair and long legs.

Now completely rebuilt as a tropical paradise, the lush resort offers 2,00 palm trees in 15 acres of gardens, pools and waterfalls.

You can photograph a flamboyance of flamingos at the Flamingo Wildlife Habitat. There are also swans, ducks, koi fish and turtles at the habitat, which is free of charge and open to the public daily.

At night, the famous feathered marquee on the southwest corner attracts gamblers, and photographers. These views are from the hotel's entrance road, by The Cromwell Hotel. Use a wide-angle lens for a dynamic perspective and impact.

✉ **Addr:**	3555 S Las Vegas Blvd, Las Vegas NV 89109	♀ **Where:**	36.115409 -115.172668
♟ **Owner:**	Caesars Ent. • 3,626 rooms • 1946	◐ **When:**	Afternoon
👁 **Look:**	Northeast	W **Wik:**	Flamingo_Las_Vegas

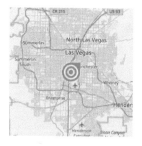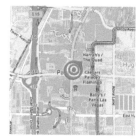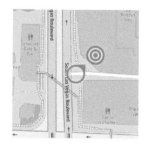

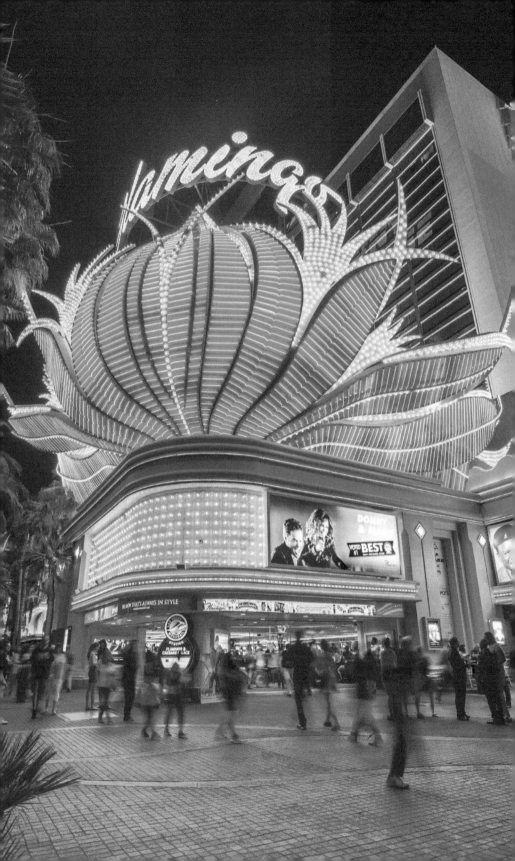

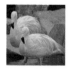
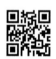

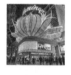

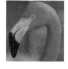

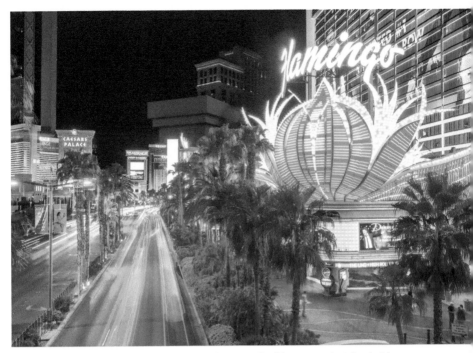

The feathered Flamingo sign can also be photographed from a pedestrian bridge over Las Vegas Boulevard.

Below: Another sign is on the porte-cochère on the south side.

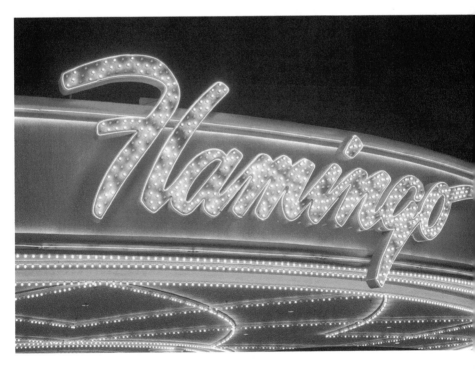

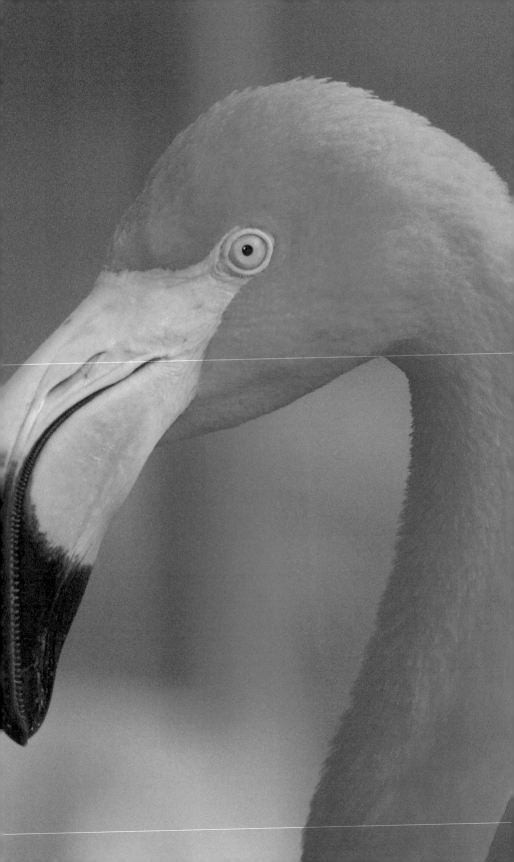

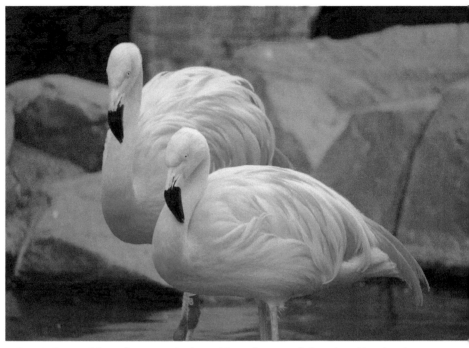

Left and above: Chilean flamingos in the Habitat. Photograph from head level and focus your lens on the eye to draw the viewer in. Below: The swimming pools from a pedestrian bridge over the gardens.

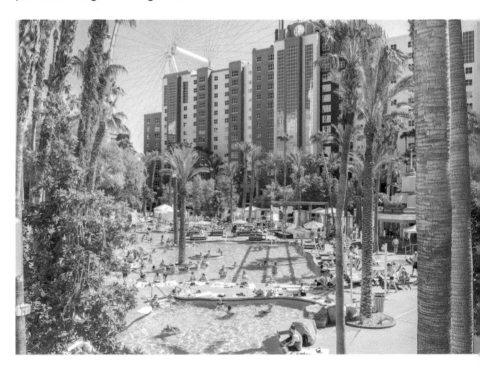

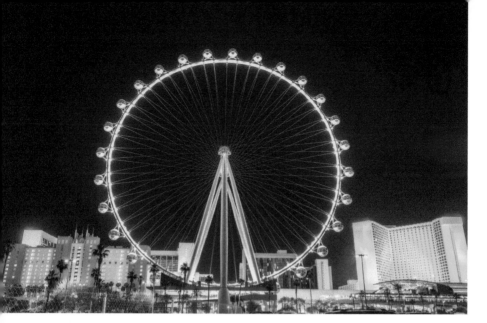

High Roller is the world's tallest Ferris wheel at 550 feet (167 m). There are 28 40-person cabins (or capsules) that individually rotate to remain level and at night, the wheel is illuminated by 2,000 LEDs.

You can photograph from the east (above), west (below left) and inside (below right, paid admission).

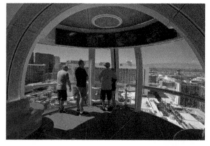

✉ **Addr:**	3969 Audrie St, Las Vegas NV 89109	♀ **Where:**	36.117484 -115.164174
👤 **Owner:**	Caesars Entertainment	☽ **When:**	Morning
🏭 **Opened:**	2014	W **Wik:**	High_Roller_(Ferris_wheel)

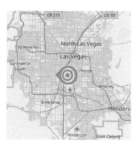

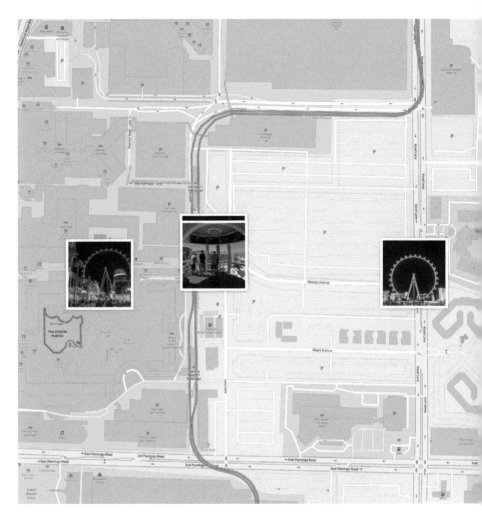

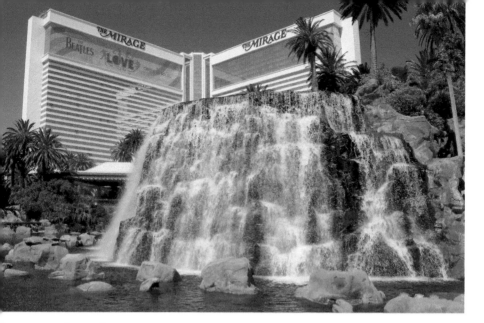

The Mirage rises like a shimmering vision in the desert. This tropical paradise has sparkling lagoons and a red rock tower that is a waterfall by day and a fiery volcano at night.

Opened in 1989, The Mirage was the first of Vegas' modern resorts, conjured by Steve Wynn to be "so overriding in its nature that it would be a reason in and of itself for visitors to come to Las Vegas."

Similar to Wynn's Bellagio, there is a 570-foot-long (174 m) lagoon designed for viewing — and photography — from the sidewalk. The volcano erupts three times per night, at 8pm, 9pm and 10pm. The show draws a big crowd and there is little front-row prime viewing area, so plan on arriving early to get the perfect spot.

Inside, the entrance to the Beatles show *Love* features a British flag on the ceiling and the Fab Four on video screens.

✉ **Addr:**	3400 S Las Vegas Blvd, Las Vegas NV 89109	♀ **Where:**	36.121263 -115.172242
⚱ **Owner:**	MGM Resorts • 3,044 rooms	◑ **When:**	Morning
👁 **Look:**	West	W **Wik:**	The_Mirage

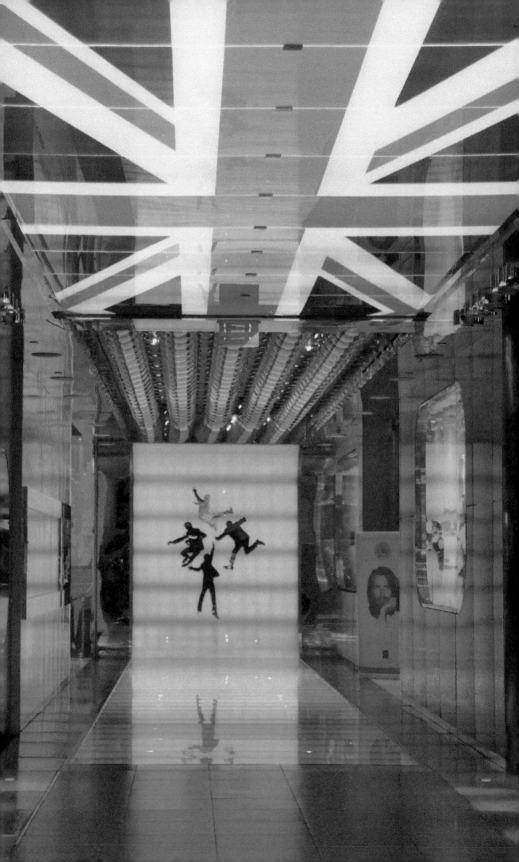

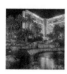

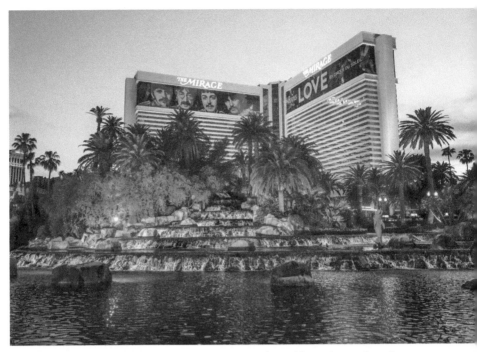

You can photograph the lagoon along Las Vegas Boulevard from the north end (above, with dolphin statues) and the south end (below). Next page: The fiery volcano explodes nightly with fire and "lava" shooting into the sky.

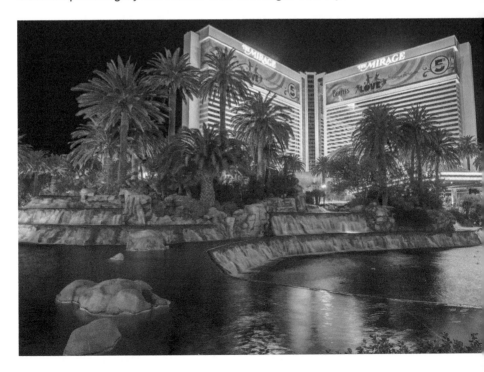

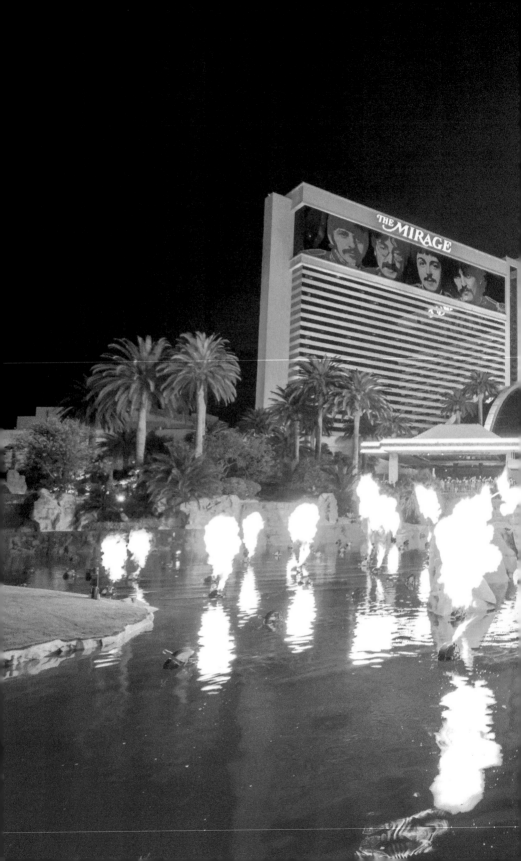

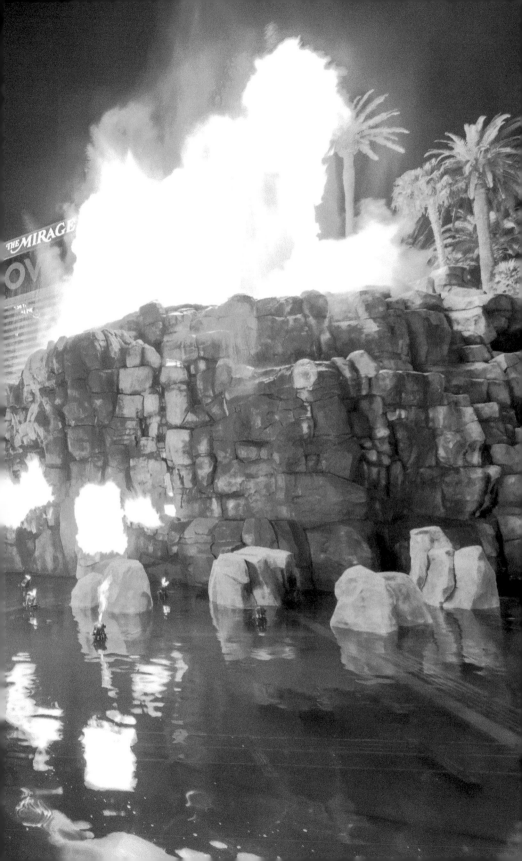

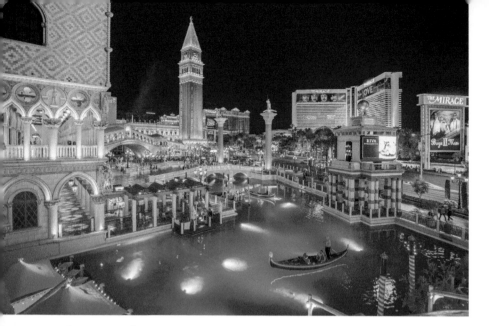

The Venetian Resort Hotel Casino is the largest hotel complex in America, and the second-largest in the world. Opened in 1999 with waterways and a Grand Canal, the resort captures the romance of Venice.

Step into a gondola, listen to the soothing sounds of a serenading gondolier, and bask in the romance of Italy's "floating city". The entrance is a recreation of the Venetian Lagoon and St Mark's Square, with approximately-full-scale reproductions of the Doge's Palace, the *Lion of Venice* column and St Mark's Campanile, plus the Rialto Bridge.

These photos are taken from the north walkway (right) and second-floor open-air gallery (above). Wait for a gondola to be in the perfect foreground position, for human interest, color and depth that makes the shot.

✉ **Addr:**	3355 S Las Vegas Blvd, Las Vegas NV 89109	♀ **Where:**	36.122762 -115.170413
☗ **Owner:**	Las Vegas Sands • 7,117 rooms	◑ **When:**	Morning
◉ **Look:**	South-southwest	W **Wik:**	The_Venetian_Las_Vegas

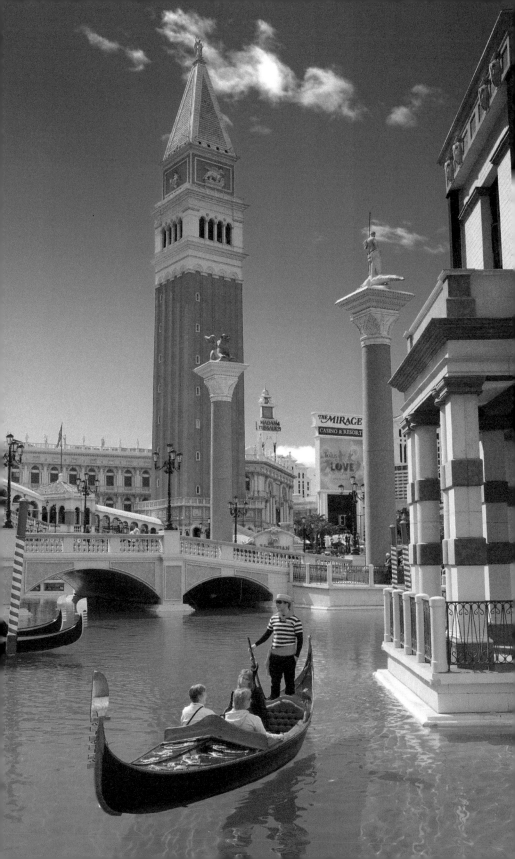

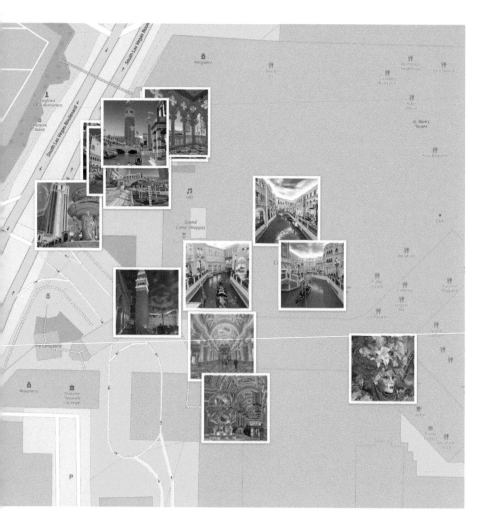

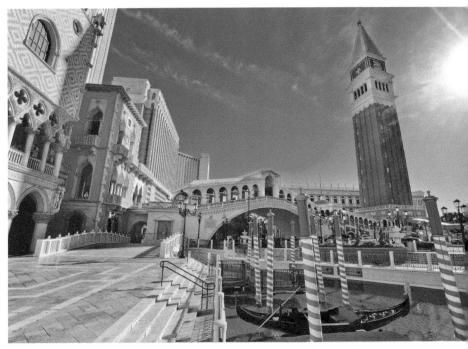

From the north end of the steps (above), you can photograph the gondolas and the Campanile. The second-floor of the Doge's Palace (below) has a long, open-air gallery with leading lines, repeating forms, and views across the Strip to The Mirage.

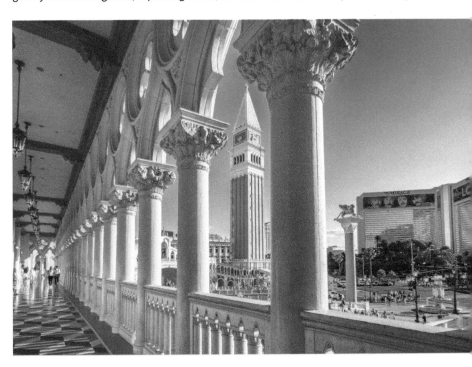

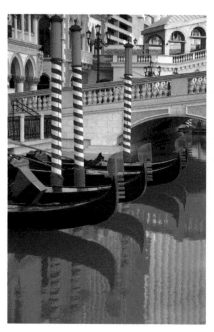

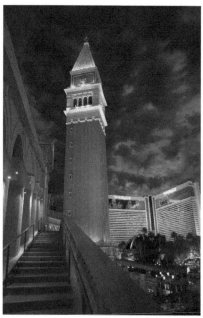

Above left: Gondolas await patrons. To add variety to your travel shots, focus on artistic details that interest you and create abstract images. Above right: Pedestrian stairs on the Rialto Bridge lead to the Campanile, lit at dusk.

Below left: Elaborate masks and costumes at the Carnival of Venice add human interest and flavor. Below right: Between the lobby and the casino is an armillary sphere, at the end of a vaulted passageway (right) decorated with Italian frescoes.

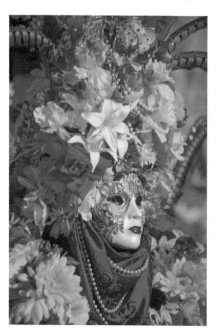

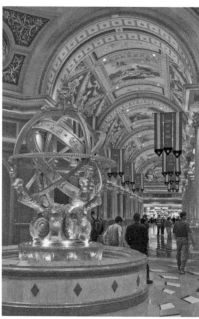

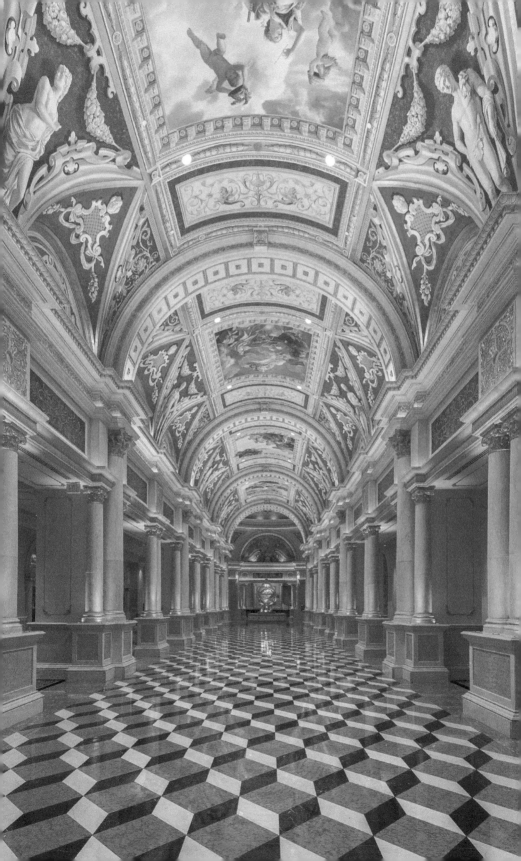

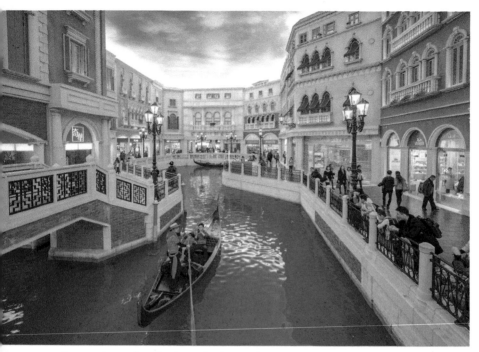

The merchant of Venice is on display at The Grand Canal Shoppes, along an indoor, 1,200-foot-long Grand Canal. You can photograph a passing gondola from one of the five bridges above the waterway.

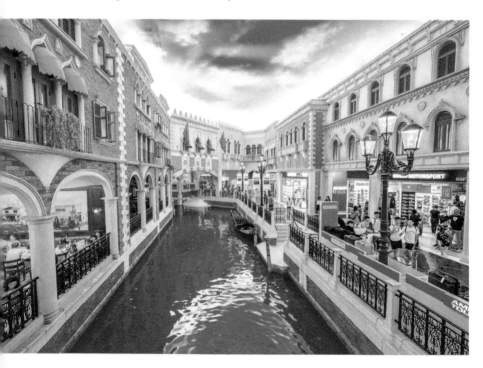

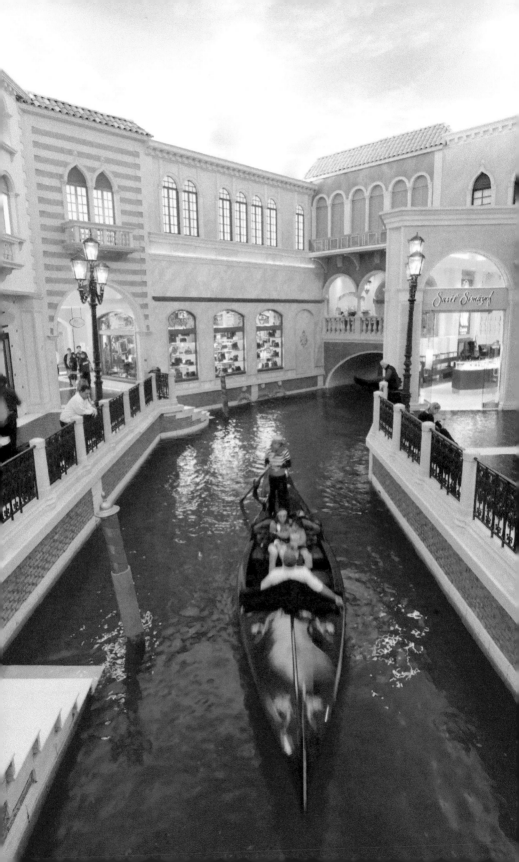

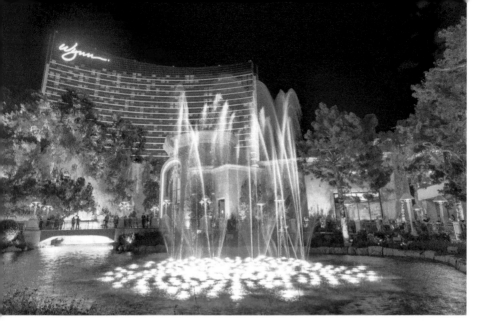

Wynn Las Vegas is the largest casino in the United States by
revenue, and is named for its proprietor, Steve Wynn, the person who
has most influenced today's Las Vegas.

Following a makeover of the Golden Nugget in 1972, Wynn
unleashed the fantasy mega-resort boom of the '90s with the Mirage
(1989), Treasure Island (1993), and Bellagio (1998). He sold them all in
2000 to concentrate on his dream and namesake.

On the southwest corner is a three-acre, man-made "Lake of
Dreams" and music fountain (above). A pedestrian bridge provides
views of an eight-story, pine-covered mountain with cascading
waterfalls (right). Use a slow shutter (around 1/8s) to get a soft curtain
of white water.

✉ **Addr:**	3131 S Las Vegas Blvd, Las Vegas NV 89109	♀ **Where:**	36.125696 -115.168712
⚲ **Owner:**	Wynn Resorts • 2,716 rooms • 2005	◑ **When:**	Afternoon
👁 **Look:**	Northeast	Ⓦ **Wik:**	Wynn_Las_Vegas

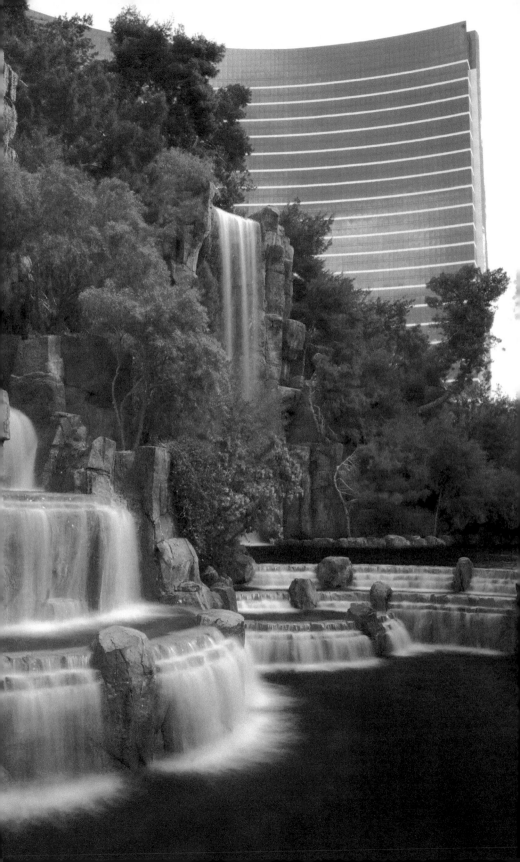

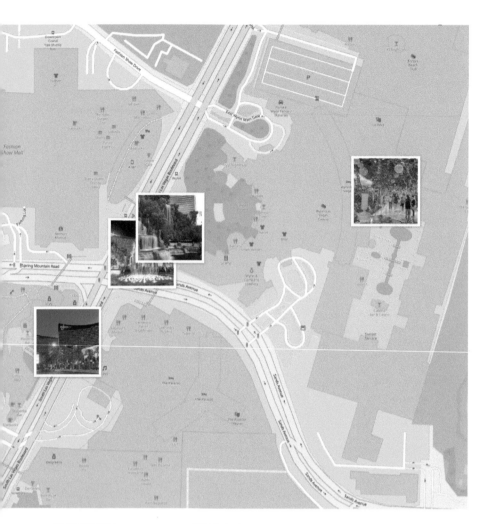

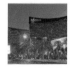

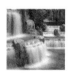

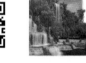

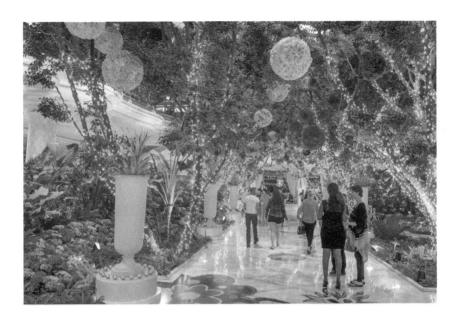

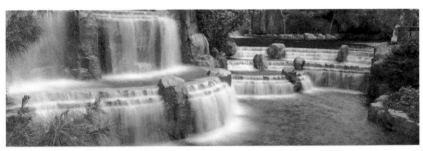

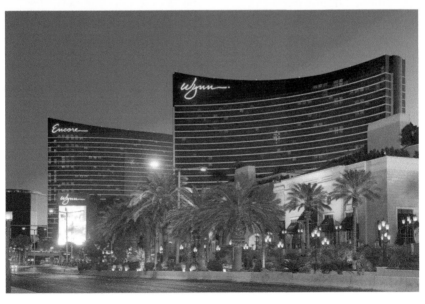

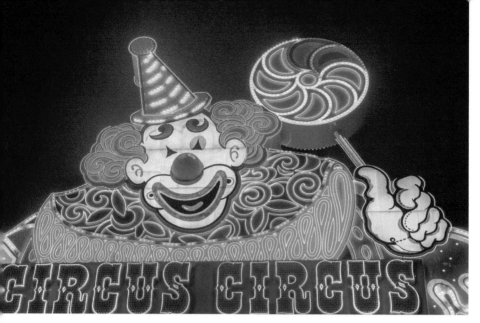

Circus Circus Las Vegas is the world's largest permanent circus. At the entrance, Lucky The Clown (above) stands 123 feet high and gestures (and jesters) you to step right up and enter the Big Top.

Every half hour, under a 90-foot-high tent, there are free grandstand shows, featuring dazzling aerialists, trapeze artists, hilarious clowns, and other circus performers. Classic fairground games can be found along the Midway amusement area. Keeping a family happy truly is like running a three-ring circus.

At the back is the Adventuredome, five-acre, indoor, air-conditioned theme park. Experience the 55 mile-per-hour speedster Canyon Blaster — the world's only indoor, double-loop, double-corkscrew roller coaster — and Rim Runner, a wet and wild ride, which drops over a 60-foot waterfall.

✉ **Addr:**	2880 S Las Vegas Blvd, Las Vegas NV 89109	♀ **Where:**	36.136449 -115.162425
⚲ **Owner:**	MGM Resorts • 3,773 rooms • 1968	◑ **When:**	Afternoon
👁 **Look:**	North-northeast	W **Wik:**	Circus_Circus_Las_Vegas

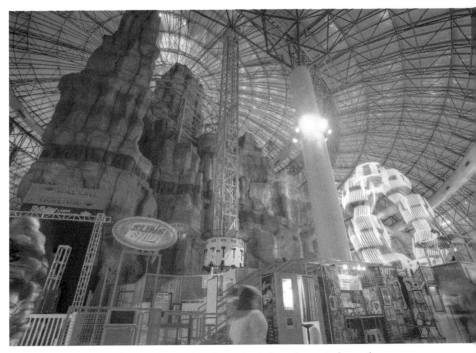

Above: The Adventuredome is housed under a giant glass dome, to keep the summer heat out, and the riders' screams in.

Below: The marquee on Las Vegas Boulevard confirms your location.

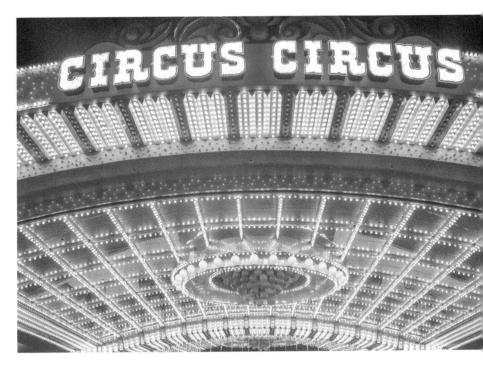

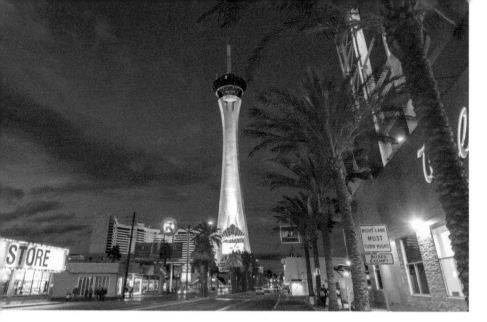

The Stratosphere Las Vegas gives you biggest high in Vegas. The 1,149-foot-tall space-needle soars over the skyline. Built in 1996, the hotel's three-legged spire is the tallest free-standing observation tower in the U.S. and can be seen from many places around the flat desert area.

The top of the tower has two observation decks — one indoor and one outdoor — on the 108th and 109th floors. Both decks provide wraparound views of the Las Vegas Valley.

The hotel is a separate, adjoining building.

To get a variety of shots (see following pages), walk Las Vegas Boulevard for 2/3 of a mile (1 km), from Sahara Avenue (city line) to Oakey Boulevard. Keep your eye out for photogenic palm trees that line the this section of the North Strip.

✉ **Addr:**	2000 S Las Vegas Blvd, Las Vegas NV 89104	♀ **Where:**	36.14392 -115.157015	
❓ **What:**	Hotel-casino	☾ **When:**	Afternoon	
👁 **Look:**	North-northeast	W **Wik:**	Stratosphere_Las_Vegas	

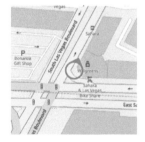

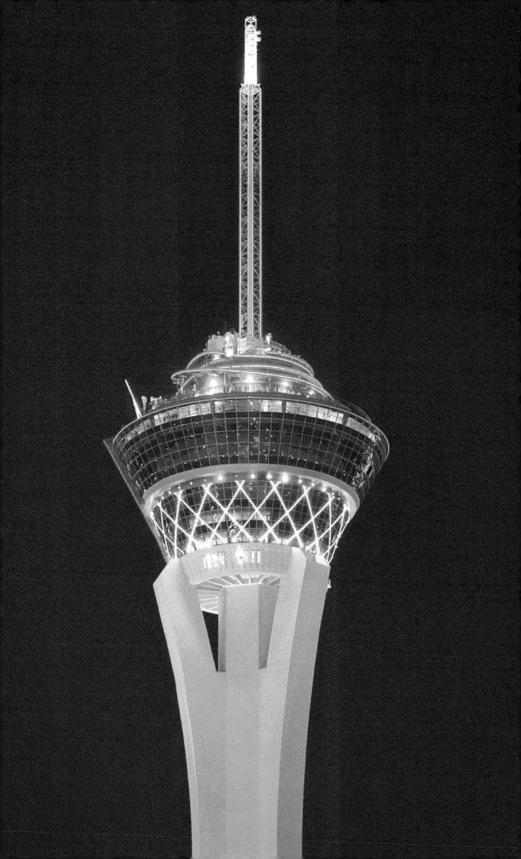

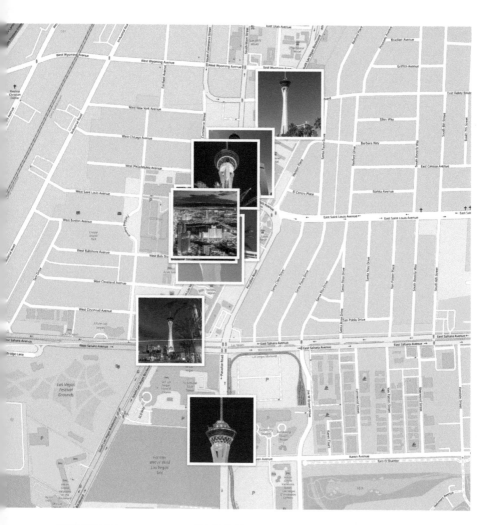

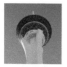 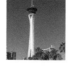 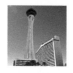

 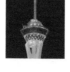

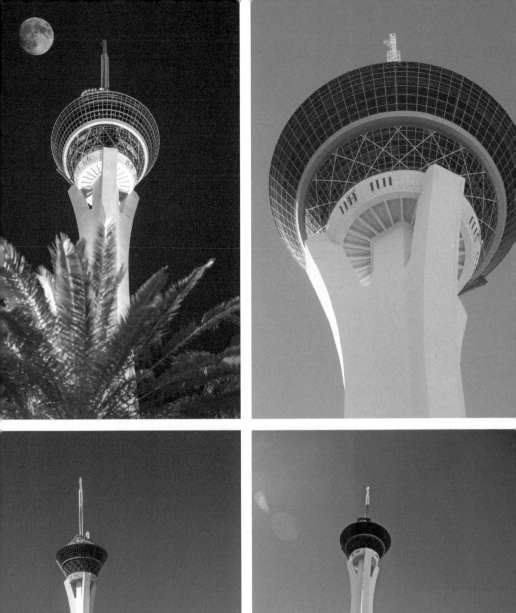

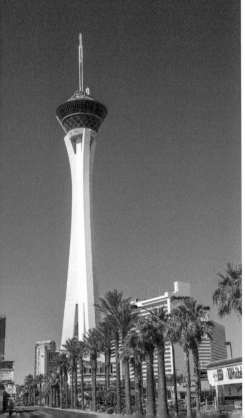

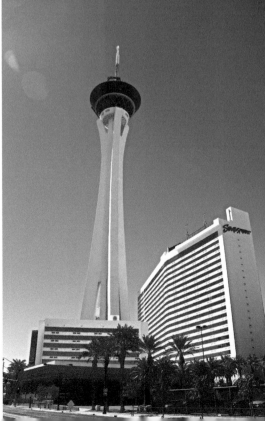

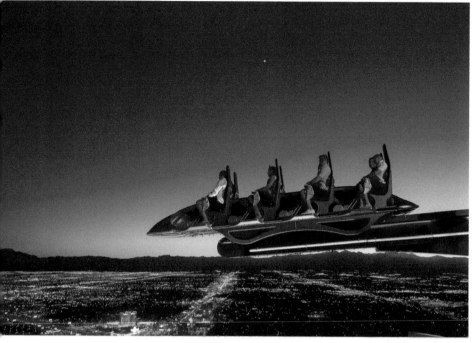

On the top of the tower are the world's four highest thrill rides — X-Scream (above), Insanity (below), Big Shot, and SkyJump. Of your own volition, you can slide, hang, or jump off the side of the tower, or be shot up the mast. And that's *before* they find out you can't pay your casino bill.

A better bet is to use your camera as an excuse to avoid such foolish activities and photograph brave riders from the outdoor observation deck.

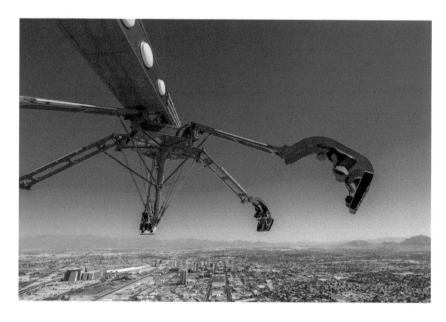

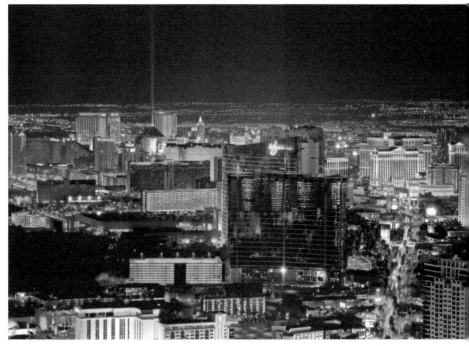

Take a ride in the tower's elevators — the country's fastest! — at the speed of three floors a second, and you'll arrive at the observation deck. Here, more than 900 feet off the ground, you're at the eye-level of passengers in passing helicopters. Nowhere else can you get such a stunning 360-degree view of the entire Las Vegas basin and surrounding mountains [paid admission].

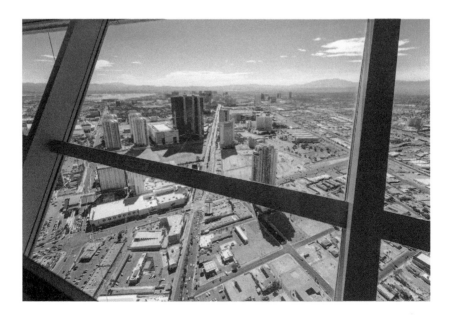

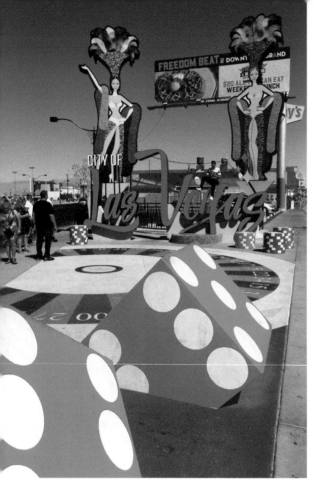

The **City of Las Vegas** sign greets northbound visitors to downtown Las Vegas with giant dice, poker chips, a roulette wheel and a pair of 26-foot-tall showgirls.

Installed in 2018, the sign emphasizes that the LAs Vegas Strip is not actually in Las Vegas but in the adjacent township of Paradise. Only as you cross Sahara Avenue by The Stratosphere do you enter the true City of Las Vegas.

✉ **Addr:**	1822 S Las Vegas Blvd, Las Vegas NV 89104	♀ **Where:**	36.148657 -115.154244
❓ **What:**	Sign	☾ **When:**	Afternoon
👁 **Look:**	North-northeast	↔ **Far:**	23 m (75 feet)

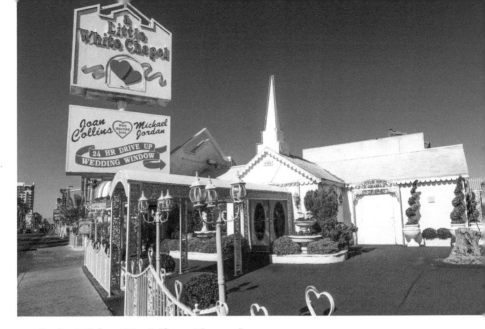

A Little White Wedding Chapel has married over 800,000 couples, including: Joe Jonas and Sophie Turner, Natalie Maines and Adrian Pasdar, Bruce Willis and Demi Moore, Frank Sinatra and Mia Farrow, and Paul Newman and Joanne Woodward. You can even do a drive-through wedding in the *Tunnel of Love*.

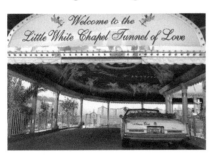

Other celebrities that tied the knot here are: Britney Spears, Sinéad O'Connor, Pamela Anderson, Eva Longoria, Michael Jordan, Joan Collins and Judy Garland.

✉ **Addr:**	1301 S Las Vegas Blvd, Las Vegas NV 89104	♀ **Where:**	36.155092 -115.149773
❓ **What:**	Wedding chapel	◑ **When:**	Afternoon
👁 **Look:**	East-northeast	W **Wik:**	A_Little_White_Wedding_Chapel

🖼 Downtown

Downtown Las Vegas is the historical heart of the city. The site of a small river in the desert, it was here that Las Vegas rose from settlement to city, and fell from religious outpost to sinful den.

The city's first hotel, Hotel Nevada (today's Golden Gate), opened in 1906. During the 1940s and 50s, downtown became known as "Glitter Gulch" due to its enthusiastic deployment of neon lighting. Today, there are 14 hotel-casinos in the downtown area, with the largest being the Golden Nugget (1946).

Between 1951 and 1962, above-ground nuclear bomb testing occurred 65 miles northwest of Las Vegas. About once a month, a mushroom cloud would rise in the distance. A booklet distributed by the government to schools in 1957 stated that "fallout can be inconvenient."

Capitalizing on the free entertainment, downtown hotels served "Atomic Cocktails" at rooftop parties to watch the show. There were "Miss Atomic Blast" contests, atom-burgers, and even the opening of the Desert Inn was timed to coincide with a blast.

In the center of downtown stands the Plaza Hotel (1971), where the railroad city of Las Vegas was started, and which still contains a working railroad station. Extending southeast is Fremont Street, with ten casino/hotels connected by the Fremont Street Experience.

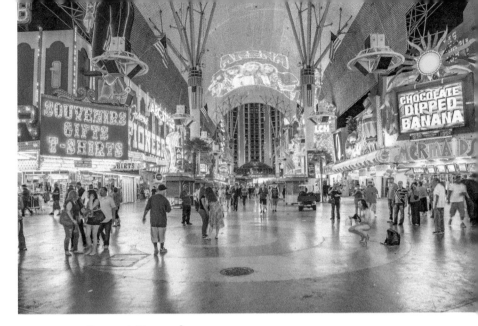

Fremont Street Experience is a four-block-long pedestrian walkway with a video canopy over casinos and shops. Opened in December 1995 on the street named for explorer John C. Fremont, the Experience has transformed the city's once-dated founding site into an award-winning pedestrian mall with spectacular free entertainment.

Each night, the $70-million marvel explodes with 6-minute-long light-and-sound shows displayed on a steel canopy 90 feet above the street. The shows — displayed since 2004 in "Viva Vision" — are a spectacle of technology and engineering, involving more than 16 million lights, 540,000 watts of concert-quality sound, 220 speakers, and 32 robotic mirrors. On hot days, the canopy even keeps people cool by spraying mist.

The Experience was created as, and is, a "must-see" attraction.

✉ **Addr:**	324 Fremont Street Experience, Las Vegas NV 89101	♀ **Where:**	36.171114 -115.145007
❓ **What:**	Pedestrian mall	⏲ **When:**	Morning
👁 **Look:**	West-northwest	W **Wik:**	Fremont_Street_Experience

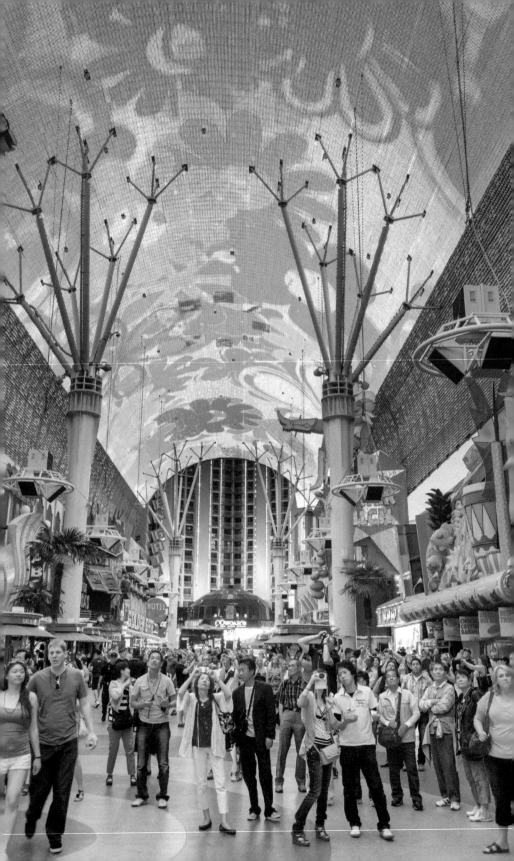

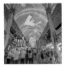

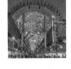

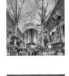

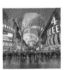

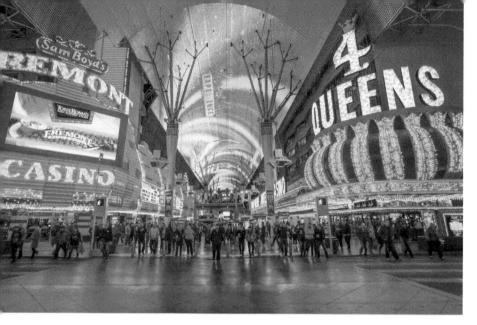

The Fremont (1956) and the Four Queens (1966) from across Casino Center Blvd.

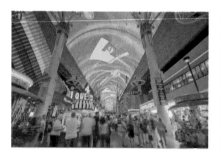

The Golden Nugget (1946) and Binion's (1951) face the Fremont and Four Queens.

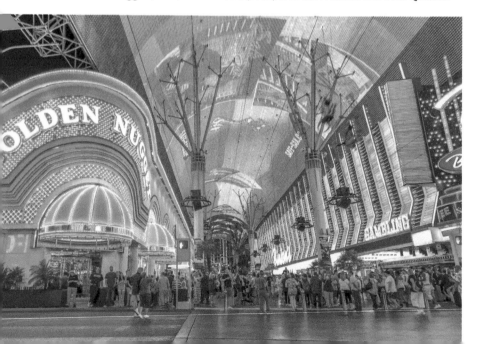

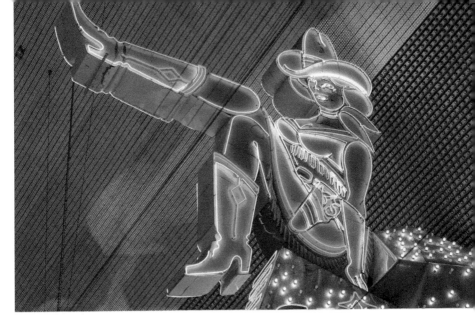

Vegas Vicki (1980, above) kicks toward 75-foot neon cowboy Vegas Vic (1951, over).

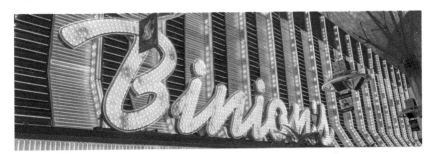

The giant Robin's Nugget (below) and Hand of Faith (over) at the Golden Nugget.

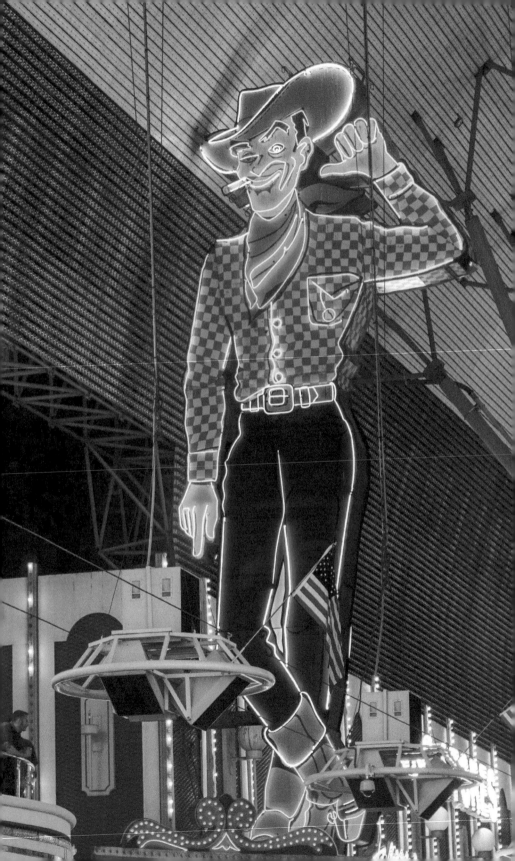

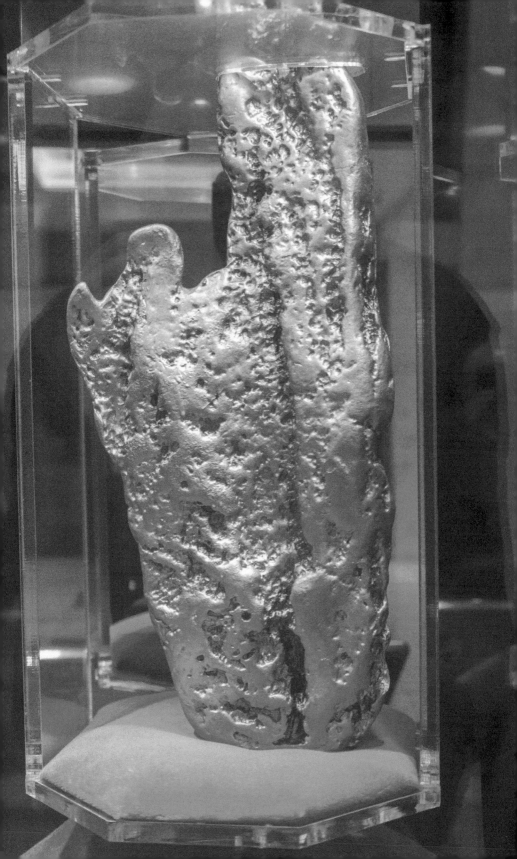

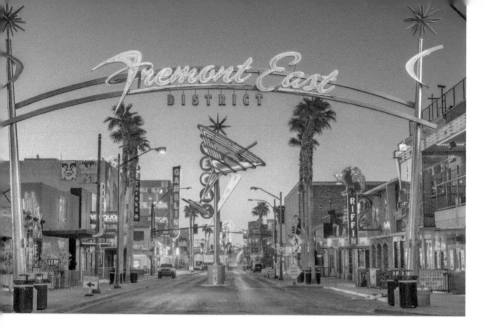

The **Fremont East District** is a three-block-long entertainment area. To elicit your camera, there are retro-looking neon Vegas signs made in 2007: the entrance archway (above), Oscar's Martini Neon Sign (right), and a Ruby Slipper (below) modeled after the Silver Slipper sign, plus the restored Hacienda Horse from 1967.

✉ **Addr:**	700 Fremont St, Las Vegas NV 89101	📍 **Where:**	36.169278 -115.140766
❓ **What:**	District	🕐 **When:**	Anytime
👁 **Look:**	East-southeast	W **Wik:**	Fremont_Street#Fremont_East

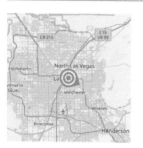
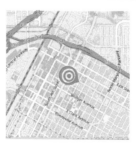
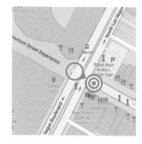

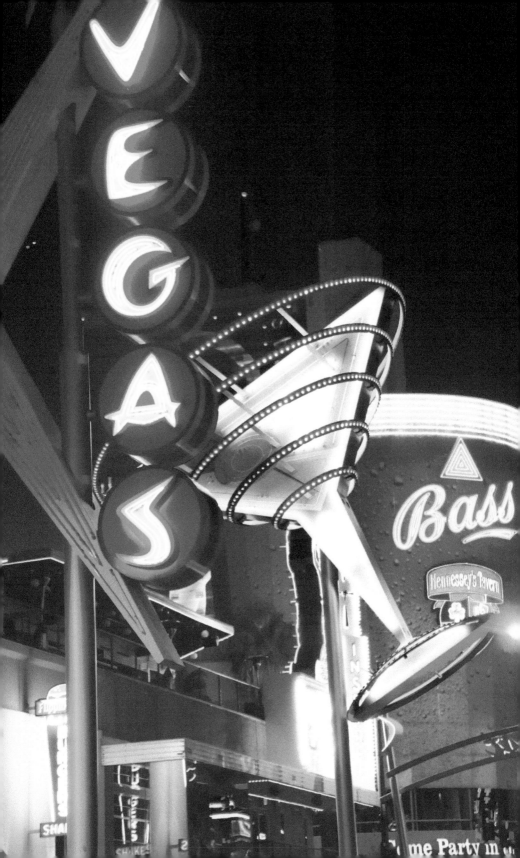

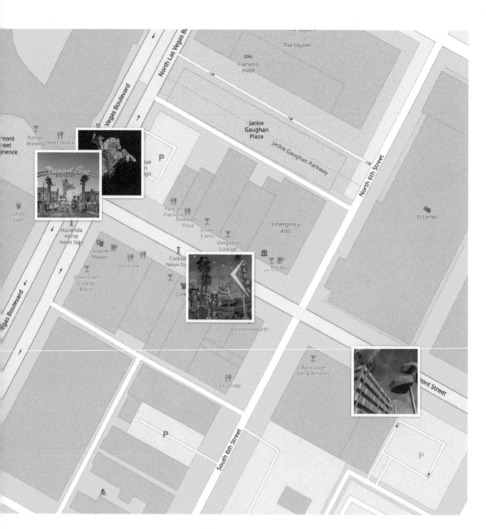

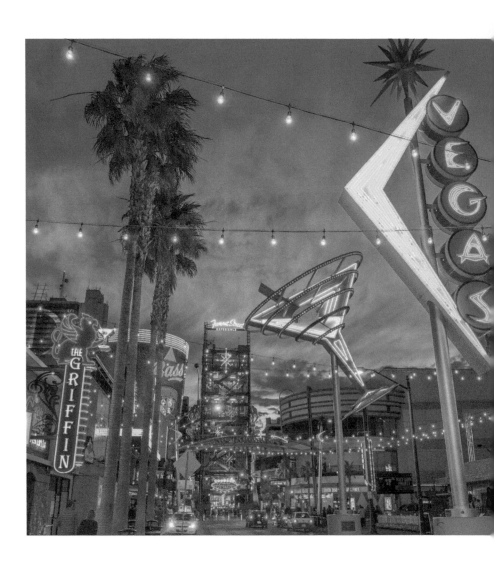

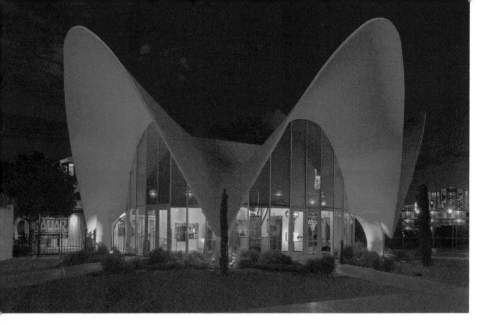

The **Neon Museum** displays vintage casino signs in a 2.6-acre "boneyard" with a wealth of photo opportunities.

The visitor center (above) is a restored lobby shell from the defunct La Concha Motel. This dusk shot is from Las Vegas Blvd North near McWilliams Avenue, where you can also capture the restored Silver Slipper (over).

Founded in 1996 to rescue an iconic sign from The Sands, the independent non-profit opened this facility in 2012. The museum is open most days from 9am to 7pm and admission is about $22 per person.

✉ **Addr:**	711 Bell Dr, Las Vegas NV 89101	♀ **Where:**	36.177068 -115.135568
❷ **What:**	Museum	◑ **When:**	Afternoon
👁 **Look:**	East-southeast	W **Wik:**	Neon_Museum

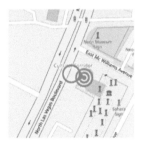

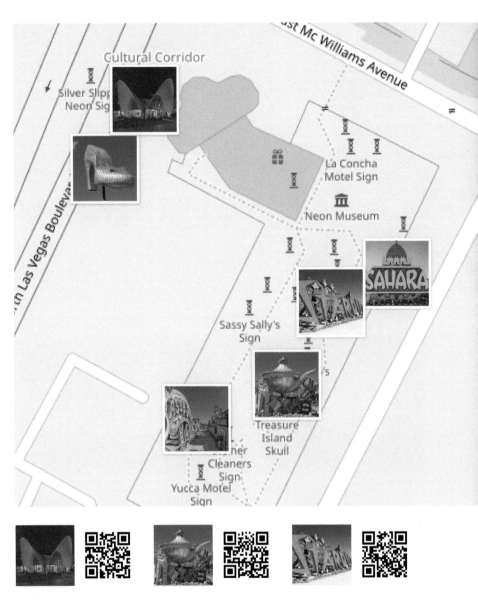

Cultural Corridor

Silver Slipper
Neon Sign

East Mc Williams Avenue

La Concha
Motel Sign

Neon Museum

Sassy Sally's
Sign

Treasure
Island
Skull

Cleaners
Sign
Yucca Motel
Sign

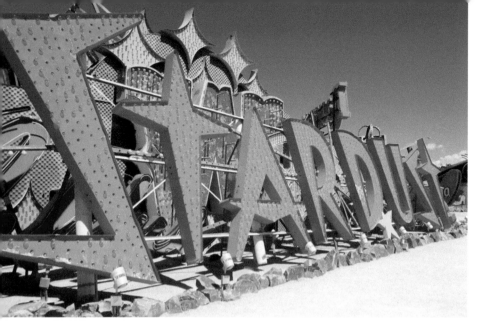

Signs of the times.

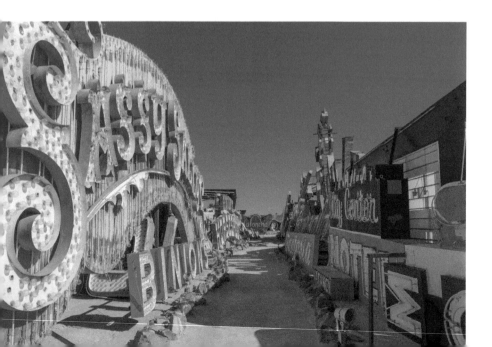

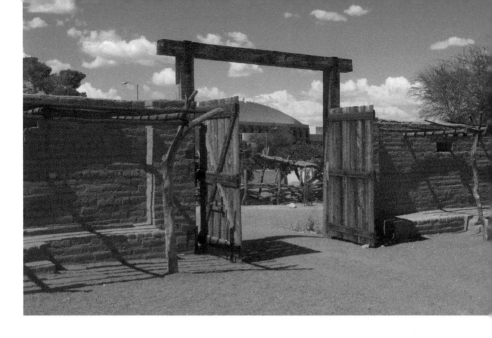

Old Las Vegas Mormon Fort State Historic Park

showcases the Old Mormon Fort from 1855, the first structure built by people of European heritage in what would become Las Vegas fifty years later. This is the only U.S. state park located in a city that houses the first building ever built in that city.

Located one mile north of downtown, the park features 14-foot (4.3 m) high adobe walls that extend for 150 feet (46 m). Admission is about $3 per person.

✉ **Addr:**	500 E Washington Ave, Las Vegas NV 89101	♀ **Where:**	36.180644 -115.133851
◑ **When:**	Afternoon	👁 **Look:**	Northeast
W **Wik:**	Old_Las_Vegas_Mormon_Fort_State_Historic_Park		

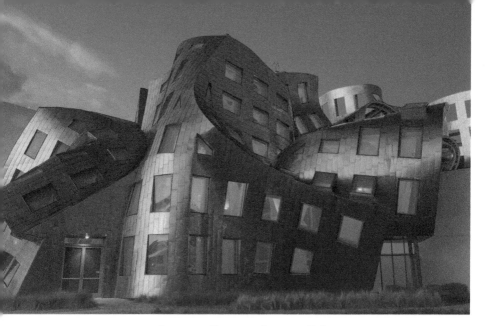

The **Lou Ruvo Center for Brain Health** was designed by the world-renowned architect Frank Gehry. This view is from Bonneville Ave at Grand Central Pkwy where you can also photograph the Clark County Government Center with a pyramid-shaped cafeteria (below) and the World Market Center (right).

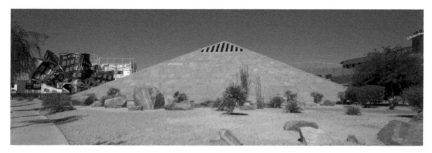

✉ **Addr:**	Lou Ruvo Center for Brain Health, Las Vegas NV 89101	♥ **Where:**	36.166865 -115.155097
❷ **What:**	Area	◑ **When:**	Anytime
👁 **Look:**	Northeast	W **Wik:**	Symphony_Park

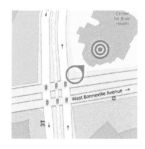

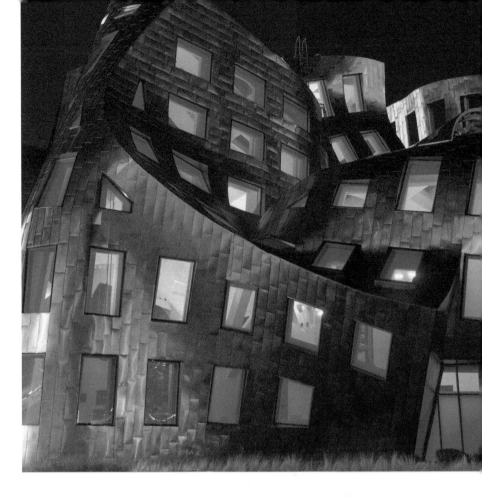

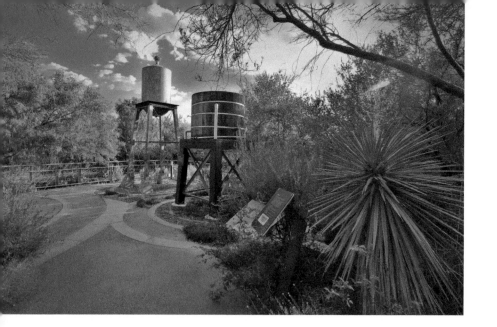

Las Vegas Springs Preserve is 180 acres of nature walks and displays around the original water source for Las Vegas, the Las Vegas Springs. There is a butterfly habitat and train rides. Admission is about $9–$19 per person.

✉ **Addr:**	333 S Valley View Blvd, Las Vegas NV 89107	♀ **Where:**	36.168718 -115.189037	
❓ **What:**	Museum	◑ **When:**	Morning	
👁 **Look:**	South-southwest	W **Wik:**	Springs_Preserve	

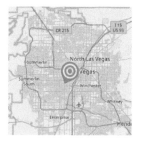
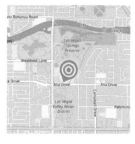

Lake Las Vegas is a 320-acre, man-made lake and Tuscan-inspired destination. There are three golf courses, a shopping and dining enclave, and three resorts: the Aston MonteLago Village Resort, the Westin Lake Las Vegas Resort, and the Hilton Lake Las Vegas.

The photographic highlight is a modern recreation of the medieval Ponte Vecchio in Florence, Italy. Like the original, the bridge has shops built along it. This view is from the southwest corner of Lake Las Vegas, at the Hilton Lake Las Vegas.

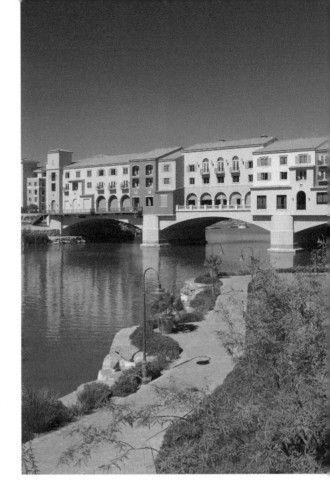

✉ **Addr:**	40 Via Bel Canto, Henderson NV 89011	♀ **Where:**	36.102927 -114.932302
❷ **What:**	Lake	◑ **When:**	Afternoon
👁 **Look:**	Northeast	W **Wik:**	Lake_Las_Vegas

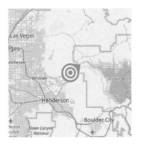

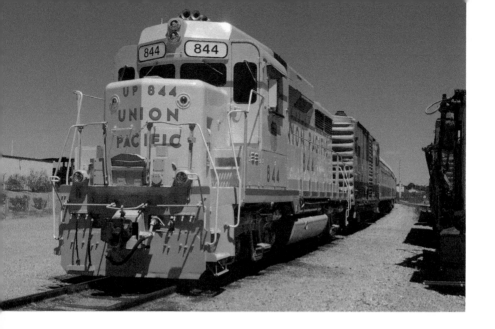

The **Nevada Southern Railroad Museum** is a heritage railway in Boulder City, about 25 miles southeast of Las Vegas.

Operating on seven miles of track installed to support construction activities at the nearby Hoover Dam, the museum offers 45-minute-long passenger excursions on historic railroad equipment.

The primary hauler is the Union Pacific EMD GP30 No. 844 (above), a diesel-electric locomotive built in 1963. There are three steam locomotives: a Baldwin narrow-gauge built in 1896, a Union Pacific #264 built in 1907, and (in disrepair) Pacific Lumber #35 built in 1923 to haul redwood logs.

Admission is around $10 for adults.

✉ **Addr:**	601 Yucca St, Boulder City NV 89005	♀ **Where:**	35.97028 -114.85667
❷ **What:**	Railroad museum	◑ **When:**	Afternoon
◉ **Look:**	North	W **Wik:**	Nevada_Southern_Railroad_Museum

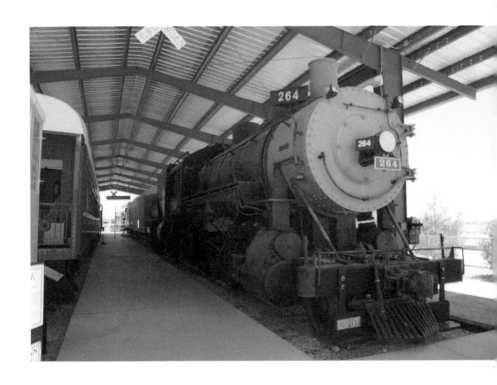

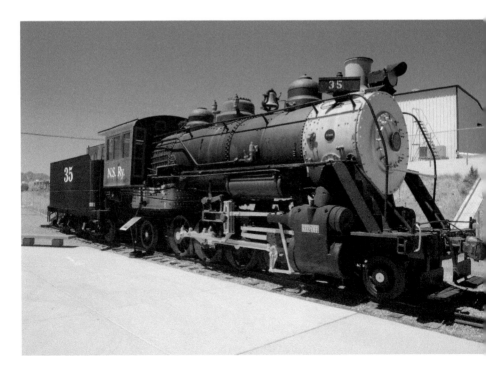

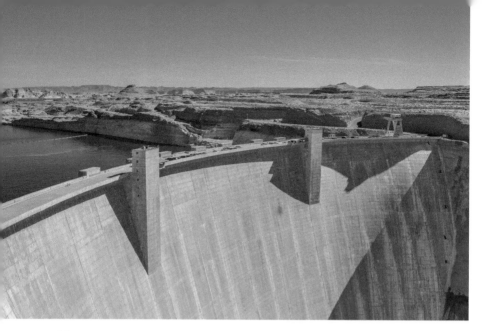

Hoover Dam is probably the most famous dam in the United States. Located 40 miles east of Las Vegas, the massive structure spans the Colorado River, at the border between Nevada and Arizona.

One of the nation's most successful public works projects and a breathtaking sight, the dam was completed in 1936 as Boulder Dam and renamed in 1947 for Herbert Hoover, an early proponent and the 31st U.S. president. Measuring 726 feet high, 660 feet wide at the base, and 1,244 feet long on the top, Hoover Dam was the first structure to contain more masonry than the Great Pyramid of Giza.

The dam provides water and power to Nevada, Arizona, and Southern California, and irrigation water and flood control for 1.5 million acres in the U.S. and Mexico. Join the flood of visitors and take all the dam photos you like.

✉ **Addr:**	81 Hoover Dam Access Rd, Boulder City NV 89005	♀ **Where:**	36.016299 -114.739205
❷ **What:**	Dam	◑ **When:**	Afternoon
◉ **Look:**	East	W **Wik:**	Hoover_Dam

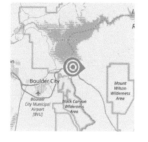 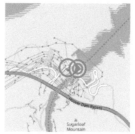 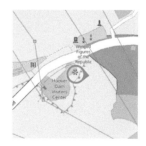

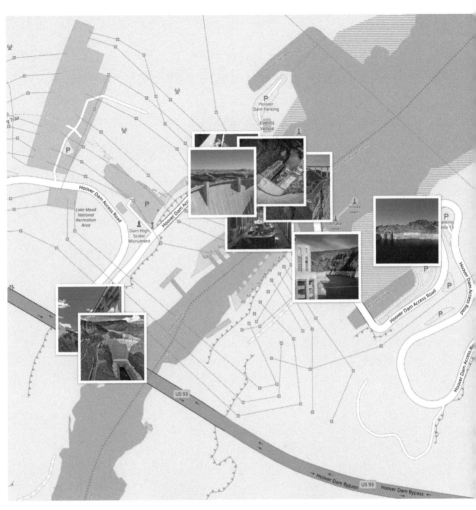

 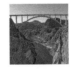

 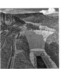

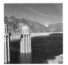

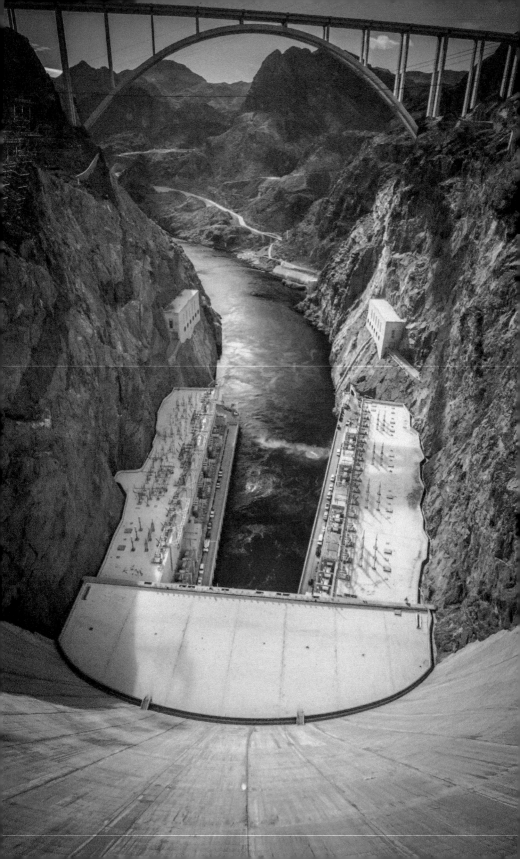

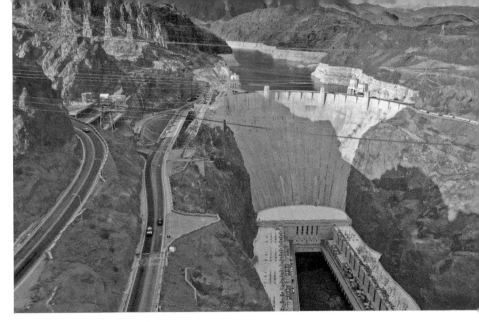

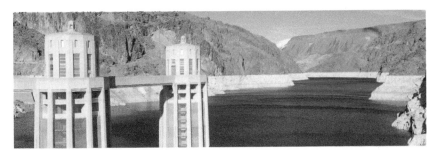

A pedestrian path on the bridge (left) offers an aerial view of the dam (above).

The intake towers (above) and scary slope (below), from a walk across the dam.

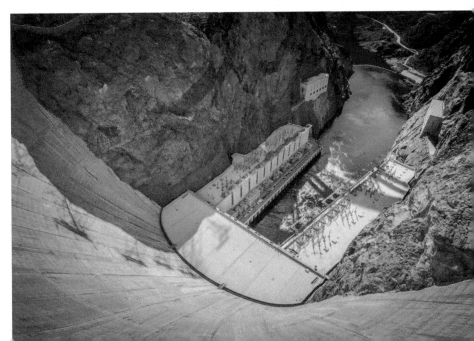

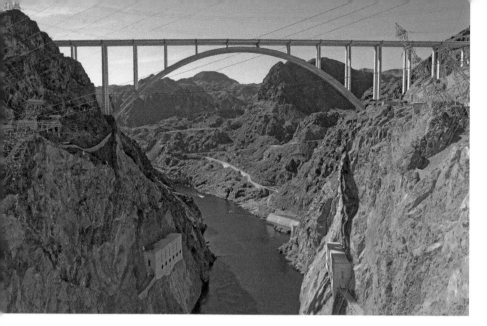

The U.S. 93 bypass bridge from the dam (above) and access road (right).

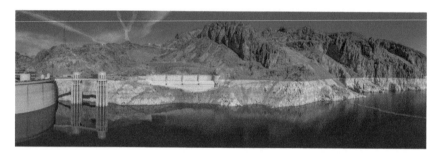

Lake Mead from the Arizona side (above), and generators on the tour (below).

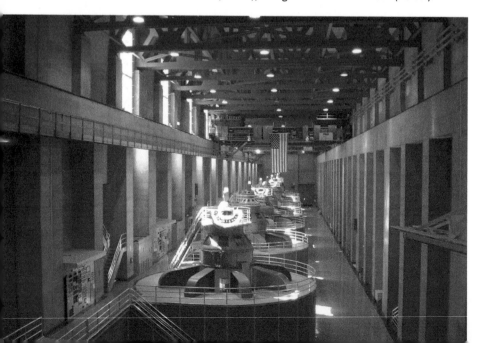

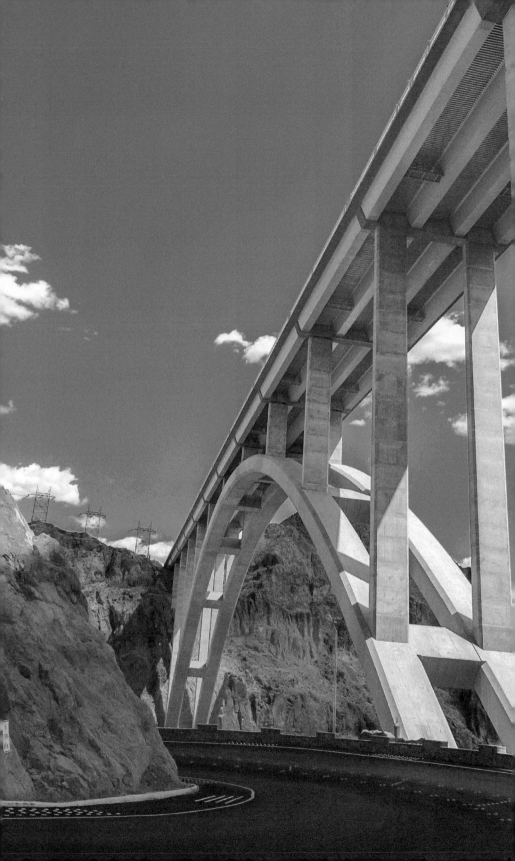

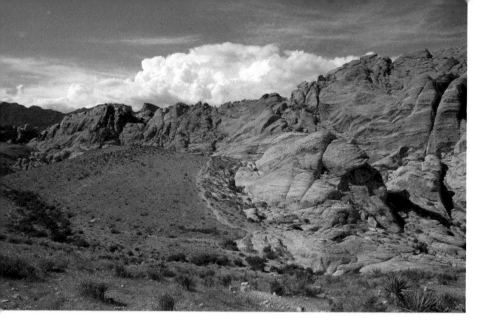

The **Red Rock Canyon National Conservation Area** is a desert preserve about 15 miles west of Las Vegas. Visitors can marvel at Calico Hills a geological thrust fault where red Aztec sandstone from the Jurassic age mixes with gray Cambrian limestone. These views are from parking areas on Scenic Loop Drive.

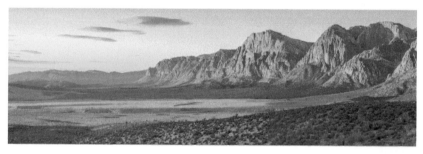

✉ **Addr:**	1000 Scenic Loop Dr, Las Vegas NV 89161	♀ **Where:**	36.1460908 -115.4307232
❷ **What:**	Area	☾ **When:**	Anytime
👁 **Look:**	Northeast	W **Wik:**	Red_Rock_Canyon_National_Conservation_Area

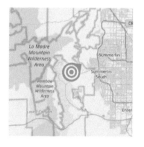

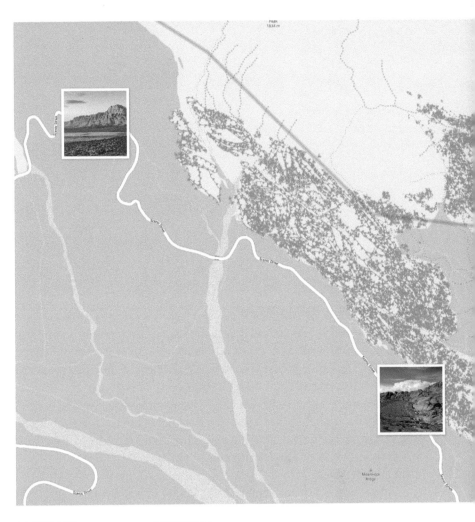

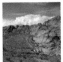 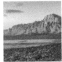

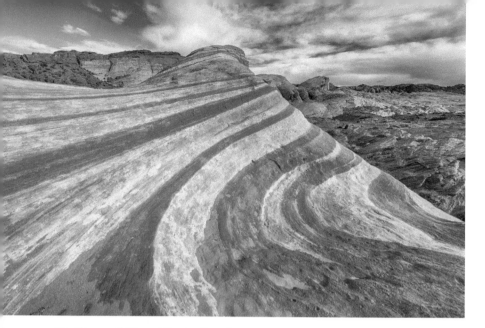

Valley of Fire State Park, located 50 miles northeast of Las Vegas, is Nevada's largest and oldest state park. Ancient petroglyphs, hidden canyons, and layer-cake colors make for an otherworldly place. The bright red Aztec sandstone outcrops stood in for the planet Mars in the Arnold Schwarzenegger film, "Total Recall" (1990).

The photographic highlight is Fire Wave (above), a swirling wave of red, white and pink sandstone. The best light is in the afternoon but you can avoid the crowds and heat by going in the morning. From the trailhead on Mouse's Tank Road, hike about 3/4 mile (1 km) to the striated outcrop.

Admission is $10 per vehicle. Take plenty of water and avoid summer heat.

✉ **Addr:**	Valley of Fire Highway, Overton NV 89040	♥ **Where:**	36.482819 -114.522448
⊙ **Fee:**	$10 per vehicle	☽ **When:**	Anytime
👁 **Look:**	Southeast	W **Wik:**	Valley_of_Fire_State_Park

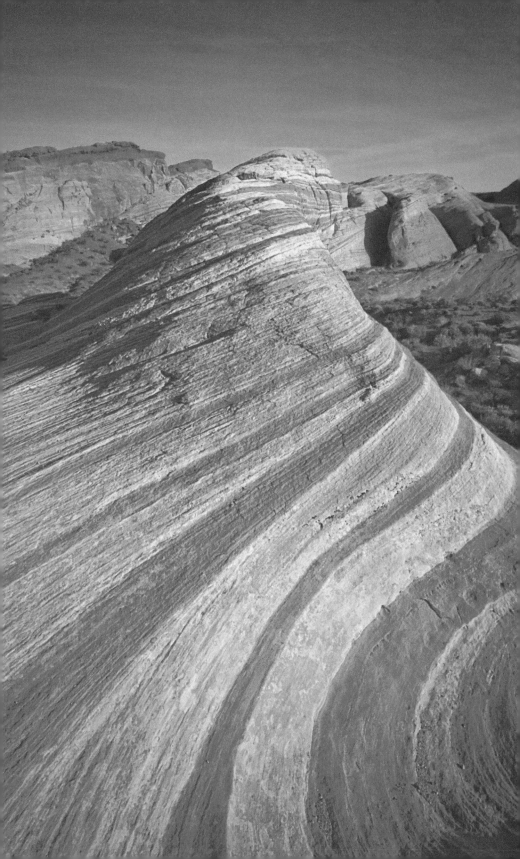

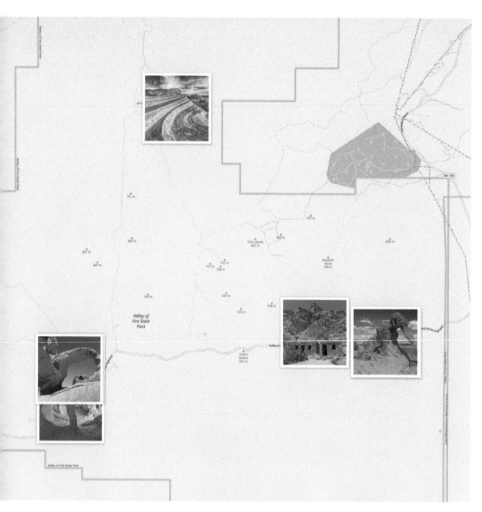

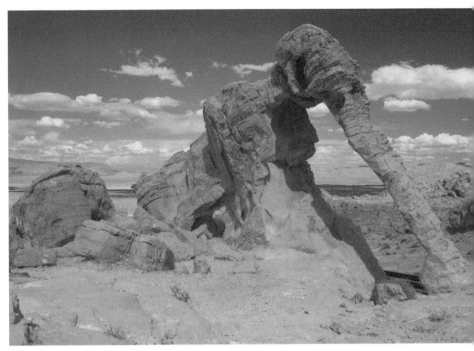

Elephant Rock is easily reached from a parking area on Valley of Fire Highway. A short hike brings you above the large, trunk-like arch, which you can photograph from both sides. Golden light of the setting sun enhances the orange and red colors. You can also use a blue/yellow polarizer for electric-blue skies and deep gold rocks.

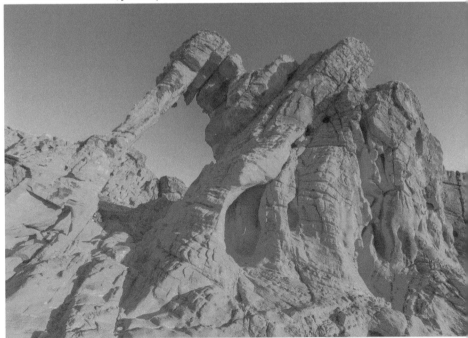

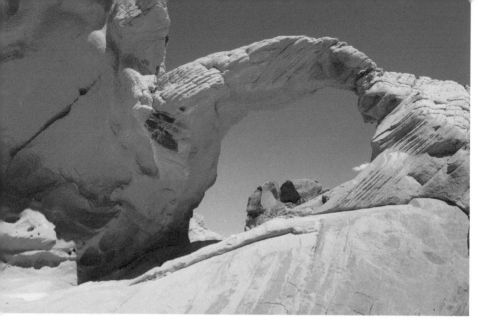

Arch Rock (above) and Fire Cave (b-r) are just off Campground Road.

Below: Rock cabins from the 1930s are reached from Valley of Fire Highway.

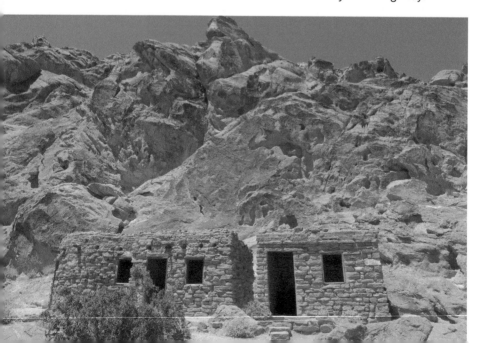

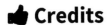 Credits

Thank you to the many wonderful people and companies that made their work available to use in this guide.

Photo key: The number is the page number. The letters reference the position on the page, the distributor and the license. Key: a:CC-BY-SA; b:bottom; c:center; e:CC-PD; f:Flickr; h:Shutterstock standard license; l:public domain; s:Shutterstock; t:top; w:Wikipedia; y:CC-BY.

Cover image by Jason Patrick Ross/Shutterstock. Back cover image by Canadastock/Shutterstock. Other images by: 4kclips (91t sh); Achinthamb (143 fy); Adteasdale (33, 35 sh); Alexanderphoto7 (42t sh); Chris Allan (77 sh); John A. Anderson (144 sh); Galyna Andrushko (149b sh); Aneese (86 sh); Anton_ivanov (43t, 78c sh); View Apart (51t sh); Atomazul (121c sh); Toms Auzins (25, 68t, 68, 71, 75, 97b, 111 sh); Andrey Bayda (25, 29, 31t, 31 fy); Gary Bembridge (142b sh); Roy Boyce (150 sh); Ceri Breeze (44, 46 sh); Canadastock (94t sh); Richie Chan (100t sh); Checubus (72, 86t sh); Jon Chica (85b sh); Ciurzynski (147 sh); Jeffrey J Coleman (52 sh); Jacqueline F Cooper (128, 130t wy); Dale Cruse (130 sh); Kobby Dagan (27, 31, 31b, 35, 36b, 42, 44t, 44, 46t, 50t, 50b, 55t, 57b, 61, 64t, 65, 66t, 66, 71, 77, 80t, 83b, 86, 91b, 98, 105t, 106t, 107b, 120, 124, 127c, 132t, 133t, 141c sh); Bumble Dee (61b sh); Deltaoff (71 sh); Songquan Deng (95, 103, 105c sh); Digidreamgrafix (140, 141b sh); Elnur (62 sh); Eqroy (50 sh); F11photo (25, 57c sh); Filip Fuxa (146t fy); Jim G (55 sh); Vladislav Gajic (98 sh); Diego Grandi (35, 83, 92, 108t fy); Renee Grayson (134t, 134 sh); Hakat (120b wl); Carol M Highsmith (132 fy); Tony Hisgett (89 fa); Matthew Hoelscher (142 sh); Phillip Holland (84 sh); Cindy Hughes (111 sh); Barnes Ian (142t sh); Asif Islam (78b wy); Alen Ištoković (133b sh); Javen (77b, 97t sh); Jenifoto (38t sh); Wangkun Jia (53, 105b fy); Paul K (121t sh); Kan_khampanya (120 sh); Zoran Karapancev (72b wa); Kuczora (142 sh); Pierre Leclerc (150 sh); Co Leong (98 sh); Edmund Lowe Photography (142c sh); Lucky-photographer (57t fa); Ken Lund (131t sh); Vadym Lysenko (86 sh); Maria Maarbes (107t sh); Paul Maguire (118 sh); Don Mammoser (42b sh); Maridav (25t sh); Benny Marty (102t sh); Maurizio de Mattei (78t sh); Aguinaldo Matzenbacher (138t fy); Joao Carlos Medau (112t sh); Crackerclips Stock Media (120t wy); Serge Melki (101 sh); M.ellinger (149t sh); Mikeledray (130 wa); Larry D Moore (115 sh); Rosemarie Mosteller (130b sh); Nagel Photography (99, 128t sh); Nan728 (65 wa); Nearemptiness (136t, 137t, 137b sh); Nick_nick (43c sh); Nito (26t sh); Nootprapa (141t fe); Bernard Spragg. Nz (32 sh); Olos (47t sh); Allard One (32 sh); Oscity (65t, 83t wa); Paulgokin (98 sh); Sean Pavone (124t sh); Denis Pepin (74t sh); Petr Podrouzek (50 sh); Gts Productions (39 sh); Joshua Resnick (25, 25b sh); Jason Patrick Ross (32t, 35 sh); Steve Rosset (135t sh); S4svisuals (121 sh); Cody Schuyler (61 sh); Shackleford Photography (144t sh); Verity Snaps Photography (64c sh); Somchaij (61t sh); Billy Stock (109 sh); Food Travel Stockforlife (100b sh); Studiolaska (81 sh); Alizada Studios (42, 48, 66, 121b, 123 sh); Arts Illustrated Studios (113b sh); Page Light Studios (124 wa); Pedro Szekely (64b sh); Travelview (37t, 111, 115t, 117t, 122 sh); Trphotos (112b sh); Tupungato (50 sh); Usa-pyon (28t, 43b, 111, 114t, 125 sh); V_e (23, 50, 69, 71, 72t, 72, 73 sh); Weichen (85t sh); Peter Wey (150t sh); Jeff Whyte (36t sh); Watch The World (79 sh); Kirayonak Yuliya (65b sh); Andrew Zarivny (22t, 41, 58t, 59, 72, 88t, 113t sh).

Some text adapted from Wikipedia and its contributors, used and modified under Creative Commons Attribution-ShareAlike (CC-BY-SA) license. Map data from OpenStreetMap and its contributors, used under the Open Data Commons Open Database License (ODbL).

This book would not exist without the love and contribution of my wonderful wife, Jennie. Thank you for all your ideas, support and sacrifice to make this a reality. Hello to our terrific

kids, Redford and Roxy.

Thanks to the many people who have helped PhotoSecrets along the way, including: Bob Krist, who answered a cold call and wrote the perfect foreword before, with his wife Peggy, becoming good friends; Barry Kohn, my tax accountant; SM Jang and Jay Koo at Doosan, my first printer; Greg Lee at Imago, printer of my coffe-table books; contributors to PHP, WordPress and Stack Exchange; mentors at SCORE San Diego; Janara Bahramzi at USE Credit Union; my bruver Pat and his family Emily, Logan, Jake and Cerys in St. Austell, Cornwall; family and friends in Redditch, Cornwall, Oxford, Bristol, Coventry, Manchester, London, Philadelphia and San Diego.

Thanks to everyone at distributor National Book Network (NBN) for always being enthusiastic, encouraging and professional, including: Jed Lyons, Jason Brockwell, Kalen Landow (marketing guru), Spencer Gale (sales king), Vicki Funk, Karen Mattscheck, Kathy Stine, Mary Lou Black, Omuni Barnes, Ed Lyons, Sheila Burnett, Max Phelps, Jeremy Ghoslin and Les Petriw. A special remembrance thanks to Miriam Bass who took the time to visit and sign me to NBN mainly on belief.

The biggest credit goes to you, the reader. Thank you for (hopefully) buying this book and allowing me to do this fun work. I hope you take lots of great photos!

© Copyright

PhotoSecrets Las Vegas, first published October 1, 2019. This version output August 15, 2019.

ISBN: 978-1930495401. Distributed by National Book Network. To order, call 800-462-6420 or email customercare@nbnbooks.com.

> *"'And what is the use of a book,' thought Alice*
> *'without pictures or conversations?'"*
> *— Alice's Adventures in Wonderland, Lewis Carroll*

© Copyright

🔨 Disclaimer

The information provided within this book is for general informational purposes only. Some information may be inadvertently incorrect, or may be incorrect in the source material, or may have changed since publication, this includes GPS coordinates, addresses, descriptions and photo credits. Use with caution. Do not photograph from roads or other dangerous places or when trespassing, even if GPS coordinates and/or maps indicate so; beware of moving vehicles; obey laws. There are no representations about the completeness or accuracy of any information contained herein. Any use of this book is at your own risk. Enjoy!

✉ Contact

For corrections, please send an email to andrew@photosecrets.com. Instagram: photosecretsguides; Web: www.photosecrets.com

■■ Index

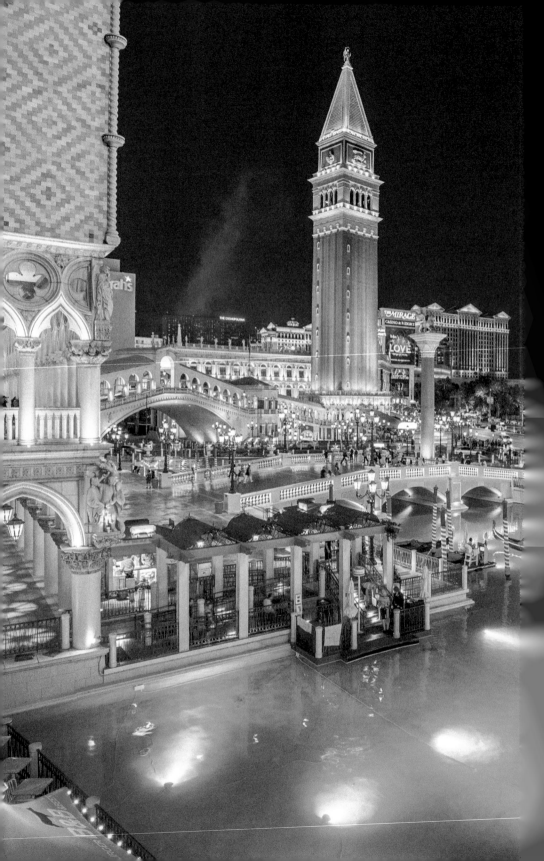

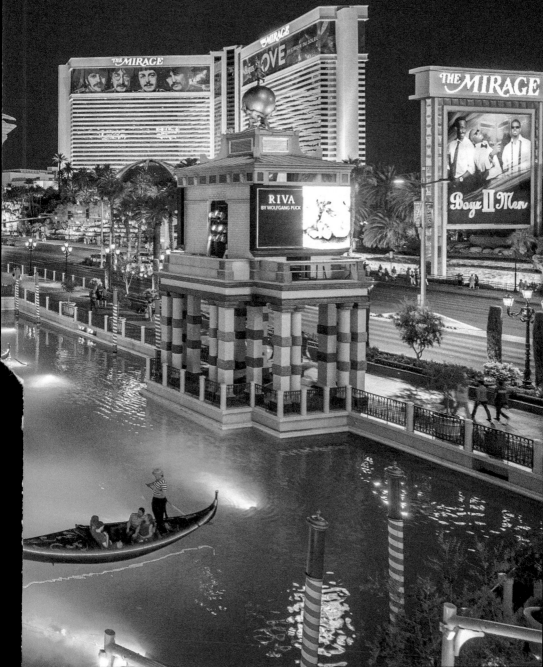

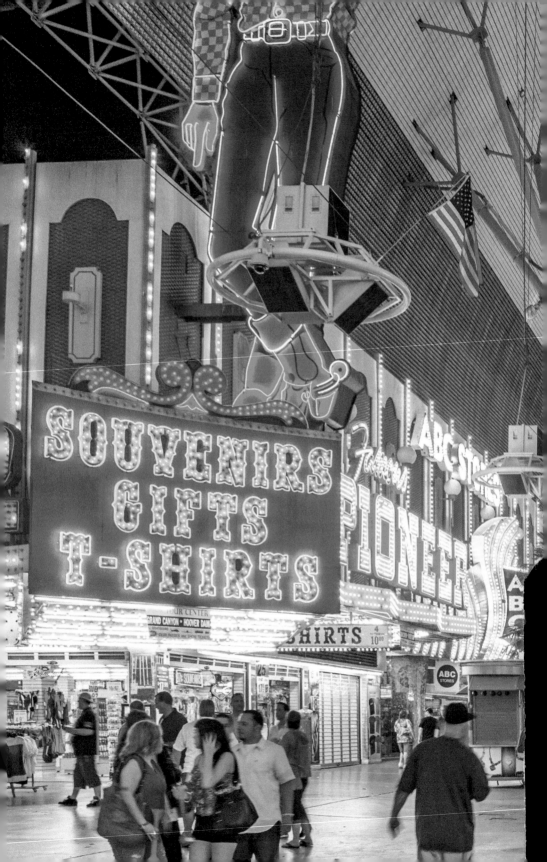

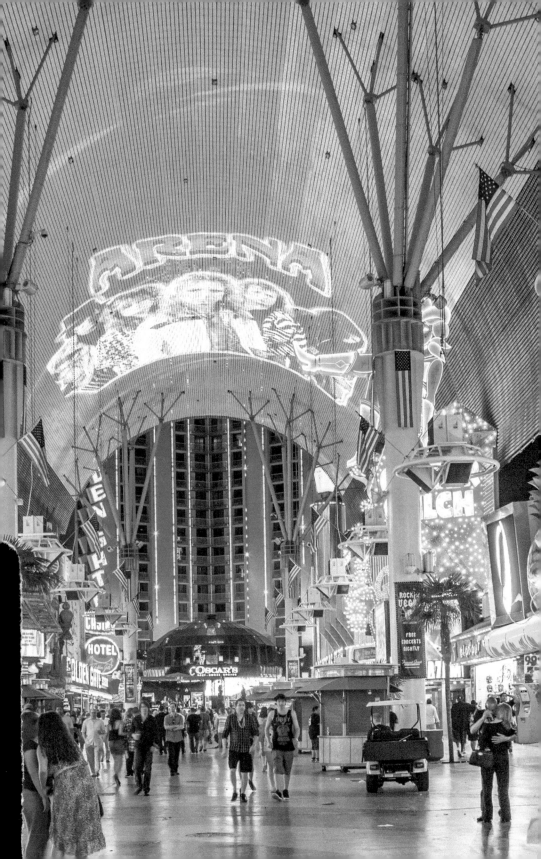

👍 More guides from PhotoSecrets